SCENIC SEATTLE

Touring and Photographing the Emerald City

Text and photography by Joe Becker

Schiffer
Publishing Ltd

4880 Lower Valley Road • Atglen, PA 19310

Other Schiffer books about Seattle:
Jet City Rewind: Aviation History of Seattle and the Pacific Northwest, Timothy A. Nelson, 978-0-7643-5106-8

Greetings from the Washington Coast: A Postcard Tour from Columbia River to the San Juan Islands, Cherie Christensen, 978-0-7643-3034-6

Published by Schiffer Publishing, Ltd.
4880 Lower Valley Road
Atglen, PA 19310
Phone: (610) 593-1777; Fax: (610) 593-2002
E-mail: Info@schifferbooks.com
Web: www.schifferbooks.com

Library of Congress Control Number: 2016934775

Designed by RoS
Cover design by Molly Shields
Type set in Avance/Swis721 BT
ISBN: 978-0-7643-5116-7
Printed in China

Text and photography by Joe Becker.
Star Wars is a trademark of LucasFilm.

Dedication

To Tanya, for joyfully putting up with hours waiting for me to
"take just one more photo."

"The bluest skies you've ever seen are in Seattle…"

—From the song "Seattle," by Hugo Montenegro, theme to
the television show *Here Come the Brides*

Contents

Preface

As a photographer, it was in my nature to write this book with an emphasis on photography because that is what I would use such a book for. It is my photographer's eye, always searching for pleasing colors and compositions, which led me to many of the places in this book. But great places to photograph are also great places to visit and enjoy without a camera. If you are not a photographer, please forgive my indulgence on photographic advice, and hopefully the book will be useful even if the only camera you use is a smartphone.

Some of the places described in the pages below are well known, while others are not. Some may take hours to explore, others only a few minutes. All are worth a visit, for their scenery, their history, or just their ambiance, whether you are a photographer or not.

SEATTLE

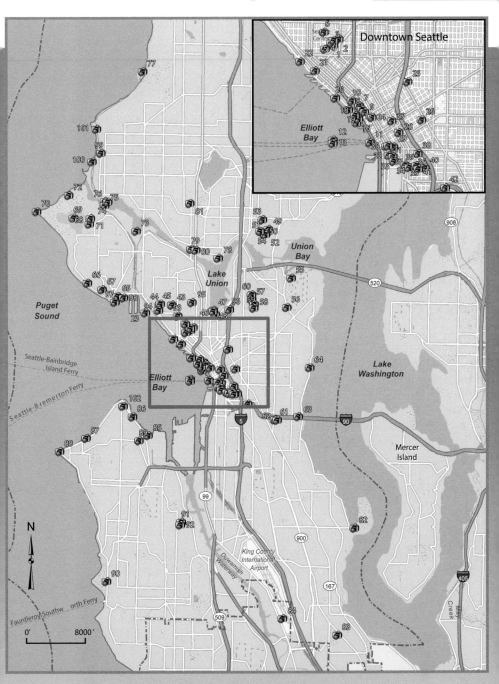

Overview map of Seattle and the more than 100 places described in this book

Pinned between Puget Sound and Lake Washington, with the Cascade Mountains to the east and the Olympic Mountains to the west, Seattle is an extremely photogenic city. In fact, Seattle was ranked as the eighth most photogenic city in the United States according to a survey conducted by Fujifilm.[1] Having been to most of the Fujifilm top ten cities, I argue that Seattle should be ranked higher. Regardless of how you might rank it, Seattle is a great place to visit with or without a camera. With its many parks, open spaces, and engaging people, Seattle is visitor friendly, and camera friendly, as well.

History, natural beauty, architecture, seascapes, landscapes, cityscapes—Seattle contains something special for every visitor. I initially created this guide to help visitors and fellow photographers find the city's special places without having to spend a lot of precious time searching. However, while I describe over 100 places to visit in Seattle, no guide is fully comprehensive. This one is designed to lead you to great places in the city with an eye toward photography, but if you have the time, you'll be able to find additional scenic or historic spots not in this guide.

Prices, hours, and contact information is provided for most attractions. It was accurate at the time of writing but does frequently change; therefore, the information is provided as a guide. Contact the attractions for current information.

Further, there are a great many scenic and historic sites outside the city that are worth exploring. Those with access to transportation can reach Mount Rainier, Olympic National Park, the San Juan Islands, the historic town of Port Townsend, the museum district in Tacoma, and much more within a day's drive of Seattle. But I had to limit the book somehow, so it only covers locations inside the city limits (with the exception of four spots on the west side of Puget Sound that are accessible by foot from downtown Seattle via ferry). I wanted the book to be usable for a visitor without transportation, so many of the locations featured in the book are accessible from downtown by foot or through simple mass-transit connections.

Weather

Seattle has a reputation for rain. Surprisingly however, it is not one of the rainiest cities in the United States. With an annual average of just over 37 inches of precipitation, the Seattle area receives less rainfall on average than Atlanta, Houston, Miami, New Orleans, New York, Philadelphia, St. Louis, Washington DC, and many other cities on the eastern seaboard. Seattle's reputation comes from the number of days with measurable rainfall—on average 155 days per year, over thirty days more than the other cities listed here.[2] Further, Seattle is the grayest major city in the United States, with heavy cloud cover[3] on average 226 days per year.[4]

Rain and gray skies present challenges to photographing in Seattle. The weather in Seattle is temperate marine, with mild, wet winters and warm, dry summers. While Seattle is one the wettest winter cities in the United States, it is also drier than the average American city from May to September.[5] Therefore, one of the best strategies

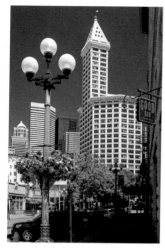

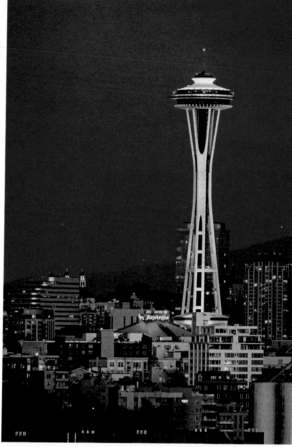

Many attractions are within walking distance of each other in downtown Seattle. The Smith Tower, for example, is adjacent to Pioneer Square.

Space Needle from Ursula Judkins Viewpoint

Downtown Seattle from Seacrest Park, West Seattle

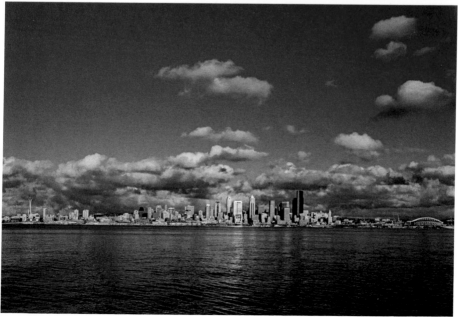

for battling the rain and cloudy skies is to visit Seattle in the summer. However, as most locals will attest, sometimes you just have to get out there and enjoy the city no matter what the weather. For photographers, actually, bad weather days can be great photography days—there are usually fewer people to deal with and bad weather can make some wonderfully dynamic skies.

CAMERA EQUIPMENT

I shoot with a digital SLR, and all the images I shot for this book were captured with one. But good shots can be taken at many locations in the book with any camera, including smartphones. Creativity is not in the camera, it's in the photographer! Still, when I mention wide-angle lenses in the location descriptions, I'm talking about 15–35 mm lenses on a full-frame DSLR; for telephoto, I usually mean 70–200 mm. This is not to say that other lenses would not be useful. Certainly, you could have fun with a fisheye lens and "big glass" might be helpful occasionally. Tripods are a helpful accessory, or a necessity, depending on the circumstances. I've tried to indicate places where tripod use is restricted.

The book is designed for use by every photographer, from casual shooters to professionals. In that regard, I've listed photography restrictions for most places that have them. However, photography policies (including tripod use) change. If you are concerned about them, I suggest contacting the venue before visiting.

⁑ Visiting in the Rain ⁑

If you happen to be visiting Seattle during a rainy stretch, you should know that often rainy days in Seattle are not really that wet. Outside of the winter months, it is rare for it to rain all day long, and even in winter such days really aren't that common. Further, heavy rains are not common either; rarely does it rain more than one inch in a day. So by picking and choosing places and times, you can stay fairly dry on rainy Seattle days.

RAIN PROTECTION FOR YOUR CAMERA

If you want protection for your camera equipment, it helps to have a rain cover. I've found inexpensive rain covers work fairly well except in big downpours. However, the covers do slow down the photographic process (which is not necessarily a bad thing). Extremely lightweight and compact, a rain cover is always in my camera bag. Inexpensive rain covers can be purchased for less than $10. I use the Rainsleeve™ by OP/TECH, but there are many others brands available (search for "camera rain cover" on Amazon).

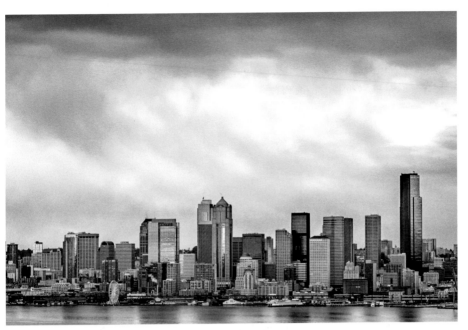

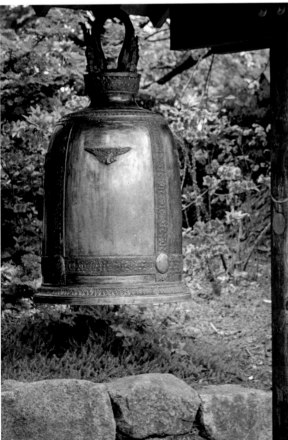

While the skies are often gray in Seattle, particularly during the winter, the city has less total rainfall than many other American cities.

Japanese bell, in Kubota Garden, a lesser-known Seattle City park

The Seattle Aquarium is a good place to visit on a rainy day, where you can see fish such as this decorated warbonnet in the Puget Sound fish exhibit.

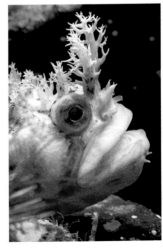

If you don't want to take the chance of getting wet, here's a list of sites you can visit and stay out of the rain:

1. The EMP
2. The Pacific Science Center
3. The Chihuly Garden and Glass
4. Pike Place Market, both in the Main Arcade along Pike Place and in the lower levels
5. Washington State Ferries
6. Seattle Aquarium
7. The Seattle Great Wheel (at least while riding)
8. The Seattle Art Museum
9. The Frye Art Museum
10. Museum of History and Industry
11. The Seattle Central Library
12. Columbia Tower (but don't go if the top of the building is in the clouds)
13. The Underground Tour
14. Klondike Gold Rush National Historic Park
15. Union Station
16. The Waterfall Garden
17. Volunteer Park Conservatory
18. The Northwest African American Museum
19. The Henry Art Gallery
20. The Burke Museum of Natural History and Culture
21. Indoor exhibits at the Woodland Park Zoo
22. The Fremont Troll
23. Museum of Flight

DEALING WITH GRAY SKIES

Even more than rain, gray skies can be a problem for photographing Seattle. Many a landscape photographer has complained, myself included, about days when the sky is totally blue, without any clouds. And even though I've repeatedly made that complaint, I'd rather have a totally blue sky than a totally gray, featureless sky. Unfortunately, gray skies are fairly common in Seattle, though much more so in the winter than other times of the year. These skies can cause real contrast problems when shooting. If you expose properly for the foreground, the sky becomes totally blown out: nothing but pure, histogram-busting white. Expose to keep some detail in the sky (if there is any to start with), and the foreground becomes impossibly dark. What is a photographer to do?

I'm tempted to say, come back another day, but if you don't live in Seattle, that isn't a very good answer, and frankly isn't true. I believe there is always something to photograph, no matter what light conditions. So, how to deal with the gray sky blues? Here are some ideas:

- *The easiest answer is to omit, or at least minimize, the sky in your compositions. Those totally gray days may not be the day to take city skyline shots, but they work well for isolating subjects against a background (such as buildings or foliage) without the sky.*
- *If the sky has some cloud detail (instead of being a totally featureless gray), consider using high dynamic range (HDR) techniques.*
- *Shoot macros and closeups—water dripping off a rhododendron bloom is a quintessential Seattle shot.*
- *Visit some of the places listed above where you can shoot indoors.*

Seattle City Parks

Many of the locations described in this book are in Seattle city parks. Seattle is blessed with an abundance of parks, many of which are great places to visit and provide wonderful photographic opportunities. The Seattle Department of Parks and Recreation, as of 2014, manages 430 parks covering 11 percent of the city's total land area.[6] Though most of the parks are not fenced or gated, most do have official open hours, generally, from 4:00 a.m. to 11:30 p.m., though hours vary depending on the park (hours for individual parks described herein are provided).

Possible Itineraries

If you only have a day or two in the city, it's always a challenge to decide what to visit. Of course, it depends on your interests, your available transportation, the weather and time of year, etc., but here are some possible itineraries for short stays. These suggestions cover many of the major sites but also provide a mix of experiences that make Seattle Seattle.

❖ One Day in the City ❖

My suggestions for visitors with only a day in the city include not just the top sites, but sites with lots of scenery (and for photographers, in case the conditions aren't perfect for that shot you've been dreaming about, you'll still have plenty to shoot).

1. Consider starting at **Pike Place Market.** Besides being one of the top Seattle attractions, the market is full of interesting subjects and also has views across Puget Sound to the Olympic Mountains. Morning is a great time to visit and photograph at the market because it is much less crowded. If you start early enough, you can wander among the vendors as they set up. Or have breakfast before you start the day at the original Starbucks (at 1912 Pike Street) or at one of the many restaurants near the market. My favorite breakfast spot is Lowell's (noted for being "almost classy since 1957") in the Main Arcade. Lowell's opens daily at 7:00 a.m. Grab one of the many window tables with views of the waterfront. If you prefer the crowds, come later in the morning. Things are usually rolling by 10:00 a.m.

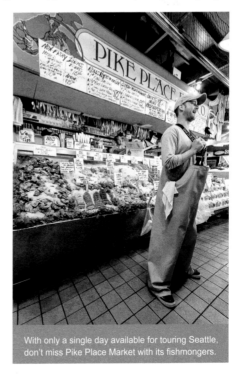

With only a single day available for touring Seattle, don't miss Pike Place Market with its fishmongers.

2. Visiting the market can easily take most the morning. From there, walk down to the **Seattle Waterfront.** The most direct walking route from the market to the waterfront will bring you downhill close to Piers 62 and 63. Walk north several blocks to take in the view from the **Bell Street Pier and Harbor,** then double back to ride the **Great Wheel** and see the rest of the waterfront. For the true Seattle experience, buy some french fries at Ivar's Fish Bar (on Pier 54) and feed the seagulls. If time permits, consider taking a ride on the Bainbridge Island ferry to view the city skyline from the water.

3. If there is still ample time before sunset, make your way to South Lake Union to visit the **Center for Wooden Boats** and wander the docks and shore area looking for nautical scenes and boat details. Be sure to visit the **Historic Ships Wharf,** as well.

4. Assuming good weather for sunset, travel up the south side of Queen Anne Hill to see the classic view from **Kerry Park.** While there, also be sure to wander west down the street to enjoy the view over Puget Sound from the **Betty Bowen Viewpoint**. Consider staying at Kerry Park until after dark to see the lights of the city.

<div align="center">✦ A Second Day in the City ✦</div>

If you have a second day in the city, you have a lot of choices. If you have transportation, you might want to get out of the downtown and visit some of the outlying parts of the city. If not, and you are on foot or using public transportation, you may wish to see the sites in the city core you missed on the first day. The following itinerary provides a little of both—a stop at Seattle Center with additional visits to the Magnolia and West Seattle neighborhoods.

1. No visit to Seattle is truly complete without a visit to **Seattle Center.** By going in the morning, you can avoid big crowds both on the grounds and at the various attractions, such as the **EMP**, the **Chihuly Garden and Glass**, or the **Space Needle**. For photographers, shooting the outside of the EMP is a must for anyone who likes abstracts. And no visit is complete without a trip to the Space Needle for a view of the city. If you don't want to pay to go up the Needle or go inside the other attractions, just wander the grounds; there's a lot to see.

2. From Seattle Center, travel north to the **Fishermen's Terminal** and spend some time walking the docks, looking at the Northern Pacific fishing fleet. If the fleet is in port, there's a lot to photograph. Then head over to the nearby **Hiram Chittenden Locks** for a look at how the US Army Corps of Engineers keeps the salt water out of the Lake Washington Ship Canal and Lake Union while letting boat traffic pass. If the season is right, you'll also get to see returning salmon in the fish ladder.

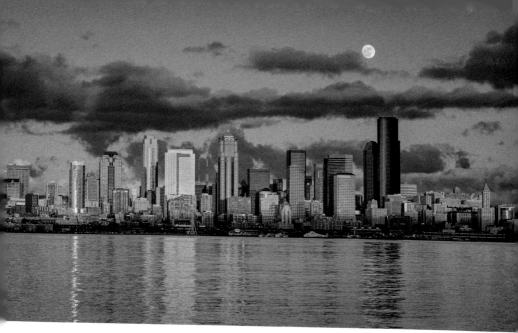

The view of the city from Seacrest Park in West Seattle is fantastic, especially at sunset.

3. While in this part of Seattle, it's worth a stop at **Gasworks Park** for a look at Seattle's industrial past and for the unique view of downtown. Be sure to check out the houseboats on the east shore of Lake Union directly across from the park. Time permitting, you may also want to check out the funky **Fremont** neighborhood on your way to Gasworks from the locks.

4. Wrap up your day with a trip to **West Seattle**. Enjoy some time on **Alki Beach**, possibly visiting the **Alki Lighthouse** if the tide is low. Near sunset, station yourself at the northern end of **Seacrest Park** on Duwamish Head. From there, looking west, you can enjoy the sunset over the Olympic Mountains, or looking east, you can see a panorama of the setting sun reflecting off downtown and the Space Needle. Consider staying until after dark for the city to light up.

Sites Listed by Topic

Of course, the itineraries on above are only suggestions. You can easily set your own itinerary based on your interests by reading this book or using one of the site lists on the next page, arranged by topic of interest.

Maritime

1. Washington State Ferries
2. Bremerton (Puget Sound Naval Museum and USS *Turner Joy* Museum Ship)
3. Center for Wooden Boats
4. Historic Ships Wharf
5. Fishermen's Terminal
6. Hiram Chittenden Locks
7. Alki Point Lighthouse
8. Smith Cove Park
9. Shilshole Bay Marina
10. West Point Lighthouse at Discovery Park

Art and Abstracts

1. EMP
2. Chihuly Garden and Glass
3. Other areas on the Seattle Center grounds
4. Olympic Sculpture Park
5. Harborside Fountain Park (Bremerton)
6. Seattle Art Museum
7. Frye Art Museum
8. Seattle Central Library
9. South Asian Art Museum
10. Henry Art Gallery
11. Fremont

Historical

1. Pike Place Market
2. Bremerton (Puget Sound Naval Museum and USS *Turner Joy* Museum Ship)
3. Smith Tower
4. Pioneer Square
5. Union Station
6. Historic Ships Wharf
7. Museum of History and Industry
8. University of Washington Main Campus
9. Discovery Park
10. Museum of Flight
11. Lake View Cemetery
12. Burke Museum of Natural History and Culture

Viewpoints

1. Kerry Park
2. Betty Bowen Viewpoint
3. Space Needle
4. Victor Steinbrueck Park
5. Washington State Ferries
6. Bell Street Pier
7. Columbia Center
8. Smith Tower
9. Rizal Viewpoint
10. Volunteer Park Water Tower
11. East Portal Viewpoint
12. Ursula Judkins Viewpoint
13. Magnolia Viewpoints
14. Jack Block Park
15. Seacrest Park
16. Alki Beach
17. Belvedere Viewpoint
18. Hamilton Viewpoint

Flowers and Gardens

1. Seattle Chinese Garden
2. Kubota Garden
3. Washington Park Arboretum and Japanese Garden
4. Volunteer Park Conservatory
5. Carl S. English Jr. Botanical Gardens
6. Parson Garden

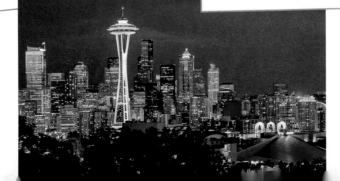

SEATTLE CENTER

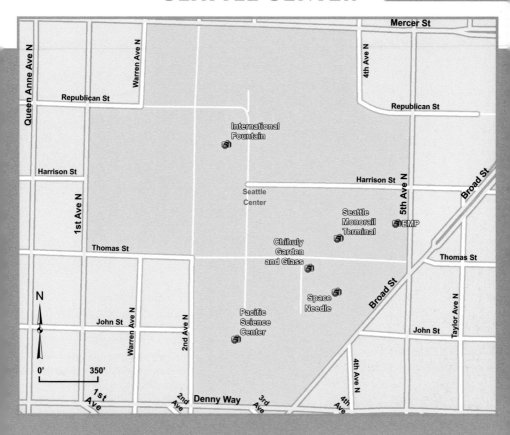

Mercer St

Queen Anne Ave N

Warren Ave N

Republican St

4th Ave N

Republican St

International Fountain

Harrison St

1st Ave N

Harrison St

5th Ave N

Broad St

Seattle Center

Seattle Monorail Terminal

EMP

Chihuly Garden and Glass

Thomas St

Thomas St

N

Space Needle

Broad St

Taylor Ave N

John St

Warren Ave N

2nd Ave N

Pacific Science Center

John St

0' 350'

4th Ave N

1st Ave

2nd Ave

Denny Way

3rd Ave

4th Ave

Seattle Center is on the site of the former 1962 World's Fair. Now over fifty years old, the fairground is still a highlight of Seattle, containing the city's most recognizable icon—the Space Needle. Rather than a static, half century-old relic, the Center continues evolving with time. While the Space Needle still dominates the grounds, new attractions have been added over the years. The most recent is the Chihuly Garden and Glass, which opened in the spring of 2012.

There is plenty to do and see on the Seattle Center grounds; a visitor could spend a whole day just at the Center and not get bored. In addition to the four attractions described below—the Space Needle, EMP, Chihuly Garden and Glass, and the International Fountain—the center is home to many theaters, the Seattle Children's Museum, and numerous open spaces with lawns and gardens.

The Center is always popular, particularly during one of the major festivals held at Seattle Center—the Northwest Folklife Festival (Memorial Day weekend), the Bite of Seattle (a weekend in July), and Bumbershoot (a music and arts festival on Labor Day weekend). Crowds are also common on weekends and warm summer days. If you are not looking to be part of the pack, you might want to go early in the day or on weekdays to avoid the crowds. For photographers, many photo opportunities can be found throughout the grounds, and those looking for people pictures will have a wealth of subjects to choose from.

Guitars, Experience Music Project Museum

Cost

It is free to enter the grounds, though many of the attractions have separate entrance fees.

Contact

Website: www.seattlecenter.com; general information: 206.684.7200.

Directions

Driving directions from I-5: Take the Mercer Street Exit (#167). At the bottom of the (long) off-ramp, continue straight onto Mercer Street. Turn left onto 5th Avenue. Seattle Center will be on your left. To reach the Space Needle, turn left onto Broad Street. Parking is available on the street or in many parking lots surrounding the Center.

■ ■ ■ ■ ■ ■ ■ ■ ■ ■ ■ ■ ■ ■ ■ ■

Space Needle (1)

There is no more iconic symbol of Seattle than the **Space Needle**. It has remained popular since it was built for the 1962 World's Fair. Arguably the best views in the city are from the Space Needle's observation deck. From there you can see downtown, the waterfront, Elliott Bay and Puget Sound, the Olympic and Cascade mountains, Mount Baker, and Mount Rainier. An elevator whisks riders to the observation deck in less than a minute for the 360 degree view of the city. However, on busy days, the wait to get on the elevator can be one hour or more. In addition to the observation deck, there is a restaurant at the top. Not surprisingly, prices at the Skycity Restaurant are on the high side.

Cost

On site, tickets for the observation deck are more expensive than those bought online. Adult online tickets are $22; prices may be higher during the peak season. When purchasing online, you need to select a date and time for your ticket, unless you buy a Flex Pass, which is good for any date or time. Tickets for a day and night admission (two visits within a 24-hour period) are $32. And for yet another option, a ticket good for both the Space Needle and the Chihuly Garden and Glass is available for $36. Access to the observation deck is also available as part of the CityPASS.

Hours

Open daily, 8:00 a.m.–midnight. The ticket booth closes half an hour prior to closing. The SkyCity Restaurant is open for brunch Saturdays and Sundays, 9:30 a.m.–2:45 p.m.; for lunch Monday–Friday, 11:00 a.m.–2:45 p.m.; and for dinner, daily between 5:00 p.m. and 9:45 p.m.

Contact

Website: www.spaceneedle.com; email: info@spaceneedle.com.

Location

The Space Needle is easily located by following the directions given on page 18 for the Seattle Center.

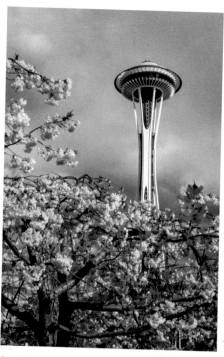
Seattle's iconic Space Needle

PHOTOGRAPHY TIPS

From the top of the Needle, use a wide-angle to normal lens to take view shots or a telephoto lens to capture and isolate details of the city or waterfront. But there's no need to ride to the top to take photos of the Needle itself. In fact, because of its height (605 feet, 184 meters), many of the best images of the Space Needle are taken from locations outside the Seattle Center grounds. On the grounds, however, there are still many good views of the Needle. Views near the International Fountain are particularly good. Near the base of the Needle, you will need to use a wide-angle lens to include the whole structure. Alternatively, compose just a portion of the Needle against the sky. Also consider using glass works at the Chihuly Garden and Glass to frame the top of the Space Needle, or capture its reflection in the polished metal sides of the EMP.

EMP (2)

Just to the northeast of the base of the Space Needle, the **EMP** is unmistakable. Formerly known as the Experience Music Project, the EMP is a popular-music museum that also houses the Science Fiction Hall and Fantasy of Fame. The oddly shaped EMP building was designed by Frank Gehry in his unique style. Built of curving, multi-colored sheet metal, the building is loved by some and hated by others (in 2002, *Forbes* magazine called it one of the ten ugliest buildings in the world). According to the *The Seattle Times*, a smashed guitar, in honor of Seattle's Jimi Hendrix, was the inspiration for the building. To come up with the design, Frank Gehry cut several electric guitars and used them as building blocks to help envision the building.[1] Today, many people believe the building does look like a smashed guitar. Personally, I don't see that, but I do enjoy the intermix of colors, curves, and reflections. Like it or hate it, it is worth spending some time outside the building.

If you like rock music and pop culture, or science fiction, a visit inside the EMP is well worthwhile. While dedicated to contemporary popular culture, the museum was built on rock-and-roll and science fiction, and these still dominate its exhibits. The museum is full of exhibits, interactive activities, and educational resources. Long-running exhibits include the *Guitar Gallery*, which describes the evolution of the guitars with displays about Orville Gibson, Leo Fender, and Les Paul and with guitars used by many rock-and-roll heroes including Bo Diddley, Eddie Van Halen, and Kurt Cobain; exhibits dedicated to Seattle rock legends Jimi Hendrix and grunge band Nirvana—these exhibits include hand-written lyrics, personal instruments, and original photographs; and the *Infinite Worlds of Science Fiction*, which covers the original *War of the Worlds* through *Star Trek* and *Battlestar Galactica* with more than 150 iconic artifacts. Other exhibits are short term, such as an exhibit dedicated to a behind-the-scenes look at the costumes of *Star Wars*, which ran through most of 2015.

Interactive and hands-on activities at the EMP include the Sound Lab and On Stage. The Sound Lab allows visitors to personally experience the tools of rock-and-roll, such as electric guitars, drums, and mixing boards. Visitors can use one of twelve soundproof rooms to try out instruments or mix in vocals. You can also record your own song, or learn to play the rock-and-roll classic "Louie Louie." In the On Stage exhibit, visitors can perform a song in the spotlight before a virtual audience of fans.

Hours
Generally open daily, 10:00 a.m.–7:00 p.m. in summer, and 10:00 a.m.–5:00 p.m. in winter, though special operating hours can occur in the peak summer season and during holidays.

Cost
Adult tickets for the museum are $25 at the museum, $22 online. Costs may be higher for access to special exhibits. Entry to the museum is also available as part of the CityPASS.

Contact
Website: www.empmuseum.org; general email: experience@empmuseum.org; public relations: 206.770.2700 or pressinfo@empmuseum.org.

Location
The EMP is at the corner of Broad Street and 5th Avenue N, just northeast of the Space Needle. Follow the Driving directions for Seattle Center on page 18.

PHOTOGRAPHY TIPS

Regardless of how you feel about its appearance, the building provides endless opportunities for abstract and reflection images. My favorite sections for abstracts are on the south and east sides of the building (near the intersection of 5th Avenue N and Broad Street), particularly where the metal sheets are green-gold and bronze. The west side offers reflections of the Space Needle. Or, try taking a photo of the Seattle Monorail passing through the building (the monorail track curves through the southwest portion of the EMP). Because the sheet metal making up the skin of the museum is highly reflective, photographing in full sunlight can be problematic due to excessive contrast. Generally, I've found my most successful images of the EMP were taken in shade, and for this reason, I recommend photographing there in late afternoon (when the east side of the building is shaded). Luckily, one of the most photogenic sections (near the southern entrance) is usually in shade and can be photographed at most times of day.

Photography inside the EMP can be difficult. Many of the exhibits are dark, requiring high ISO settings, as tripods (and monopods) and flash photography are not allowed. Plus, there's the need to manage reflections off the exhibit glass and to watch out for exhibition lights shining directly in the lens. In museums such as this, I prefer tight shots of individual components in the exhibits, or even portions of an exhibited object (just the headstock of a guitar, for example). Tight shots help avoid the reflection and stray light issues. You can also avoid these issues by photographing one of the most striking displays in the EMP that is not behind glass—the guitar tower. I enjoy isolating details of the hundreds of guitars (and other musical instruments) that make up this "sculpture." The guitar tower can be photographed from both the lower and upper levels of the EMP.

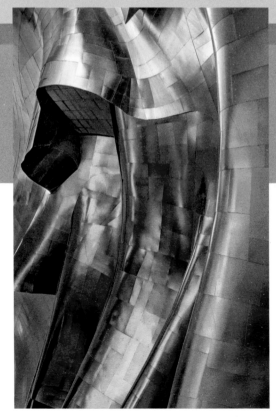

PHOTOGRAPHY RESTRICTIONS

No flash photography, tripods, or monopods in the museum galleries. For commercial photography inside the EMP, contact the museum's public relations staff.

The EMP is known not only for its music and science fiction exhibits but also for its fascinating architecture.

Chihuly Garden and Glass (3)

Chihuly Garden and Glass is one of Seattle's newer attractions, having opened in 2012. The exhibit, in Seattle Center just west of the Space Needle, is dedicated to the unique glass artwork of Dale Chihuly, a Washington native. It includes eight galleries filled with glass artworks, three "drawing walls," a forty-foot-high glass house where natural light bathes a 100-foot-long hanging glass sculpture, a theater showing short videos on Chihuly's working process, and an outdoor garden with a mix of plants, flowers, and glass artworks. Many of Chihuly's works are exhibited en masse, providing endless possible photographic compositions by isolating different glass

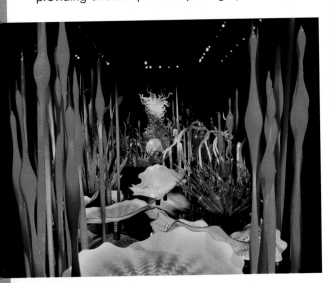

elements and filling the frame with color. As the garden is close to the base of the Space Needle, you can frame the Needle with some of the taller glassworks. The garden is artfully lit in the evening.

Colorful glass artwork in a gallery inside the Chihuly Garden and Glass, *courtesy of Chihuly Studio*

PHOTOGRAPHY RESTRICTIONS

Photography is allowed for personal, non-distributional, non-commercial use only. Flash photography, video cameras, tripods, and monopods are prohibited. For commercial photography, contact media/community relations.

Cost

When purchasing online, you need to pick a day and time for your visit. Adult tickets are $22. Tickets may be more expensive at the door and prices might be higher during the peak season. A combination ticket that includes the Space Needle's observation deck is $36. Entry to the Chihuly Garden and Glass is also available as part of the CityPASS.

Hours

Opens daily at 8 a.m. and closes Monday–Thursday at 9:00 p.m. and Friday–Sunday at 10 p.m. It occasionally closes early for special events.

Contact

Website: www.chihulygardenandglass.com; phone: 206.753.4940; general email: info@chihulygardenandglass.com; media/community relations email: pr@chihulygardenandglass.com.

Location

The Chihuly Garden and Glass is just west of the Space Needle. Follow Driving directions for the Seattle Center on page 18.

Pacific Science Center (4)

The **Pacific Science Center** contains various educational, scientific exhibits as well as an IMAX theater and a planetarium. There are nearly twenty permanent exhibits, including *Dinosaurs: A Journey Through Time,* featuring seven life-like robotic dinosaurs; *Insect Village,* with interactive exhibits and live animal displays; *Professor Wellbody's Academy of Health & Wellness*, where the many interactive exhibits allow visitors to see their future selves and dodge flying particles at the Sneeze Wall; and *Adventures in 3Dimensions*, which explores (in three dimensions) how technology and the human mind work. Additionally, there is always one or more featured, temporary exhibits (at the time of this writing, for example, the Science Center featured an exhibit called *Grossology: The (Impolite) Science of the Human Body*).

The Science Center is formed by a collection of buildings surrounding a large courtyard with reflecting pools and fountains. Above the courtyard are five delicate white arches. The arches are lit at night, often with colors that change with the seasons, holidays, or special events.

Even if you are not particularly fond of science, a good reason to pay for admission is to visit the Tropical Butterfly House, a 4,000-square-foot area filled with tropical vegetation and butterflies from Central and South America, Africa, and Asia. According to the Science Center's website, it is designed to be an immersive exhibit providing a glimpse into a very un-Seattle-like part of the world "where colorful butterflies are active 365 days per year." The Science Center imports approximately 500 butterflies weekly, so there are always many colorful wings to see, and new butterflies are released into the butterfly house each morning.

PHOTOGRAPHY RESTRICTIONS

No flash photography or tripods are allowed inside the buildings. The Science Center's media relations manager notes that commercial photography of the exhibit halls and the buildings' architecture is prohibited. Photographers with clients can, however, rent space in the facility. Contact Ms. Del Buco for more information.

Hours
Open weekdays, 10:00 a.m.–5:00 p.m., and weekends and holidays until 6:00 p.m.

Cost
Basic adult tickets are $19.75; additional costs for IMAX, planetarium, laser shows, and special exhibits. Also available as part of the CityPASS.

Contact
Website: www.pacificsciencecenter.org; general email: gs@pacsci.org; media relations manager Katelyn Del Buco: kdelbuco@pacsci.org.

Location
The Pacific Science Center is at the southwest corner of Seattle Center. Driving directions to Seattle Center are on page 18.

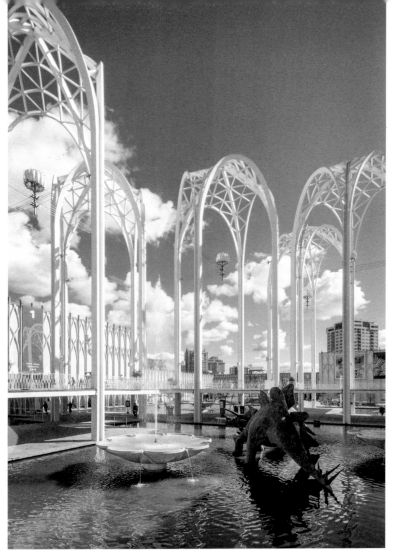

Courtyard of the Pacific Science Center

PHOTOGRAPHY TIPS

Like the EMP, much of the photographic value of the Science Center is in the building itself. Because of the arrangement of the Science Center buildings, images of the courtyard can only be taken from a limited number of spots near the entrance or by paying for admission to get into the courtyard itself. However, various shots of the entire structure or the arches (which extend high above the buildings) can be made from several locations on and off the Seattle Center grounds. After dark, the building is great for night shots because of the illuminated arches.

The other main item of interest to photographers is the Tropical Butterfly House. When in the Tropical Butterfly House, consider using a macro lens (or a telephoto zoom with diopters), potentially with a monopod. Because the exhibit is very popular, especially with children, the staff sometimes limits the number of visitors inside. Try going early in the day or on a weekday to help avoid crowds.

Seattle Center Monorail (5)

Another of Seattle's icons, the **Seattle Center Monorail**, connects the Seattle Center with Westlake Center (a major shopping area) in downtown Seattle on a one-mile elevated track. The monorail was originally built for the 1962 World's Fair and consists of two trains: the Red Train and the Blue Train, each of which run on separate tracks. Each train can hold up to 450 passengers. Together, the two monorail trains typically carry about 2,000,000 passengers each year.[2] The trains reach a maximum speed of 45 miles per hour, and a one-way ride between the two stations takes about two minutes. The trains leave each station about every ten minutes.

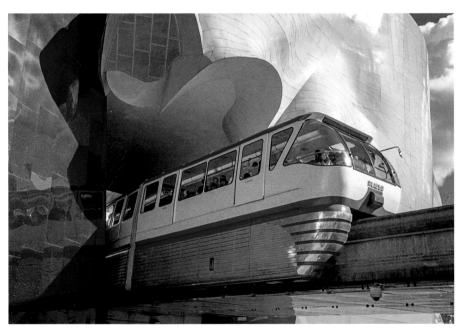

The Seattle Monorail as it travels through the EMP Museum

Hours
Operates 7:30 a.m.–11:00 p.m., Monday through Friday; 8:30 a.m.–11:00 p.m. on weekends. Hours may vary during holidays and special events, and it is closed on Thanksgiving and Christmas.

Cost
One-way adult tickets are $2.25.

Contact
Website: www.seattlemonorail.com; phone: 206.905.2620.

Location
The Seattle Center terminal for the monorail is immediately north of the Space Needle. Driving directions to Seattle Center are on page 18.

International Fountain
and Seattle Center Grounds (6)

When visiting the major attractions at Seattle Center, it is well worth wandering the grounds. The Seattle Center grounds are a large park in the midst of the city, containing numerous open spaces with lawns and gardens, in addition to buildings. There is also scattered artwork worth exploring; a large bell from Kobe, Japan, one of Seattle's sister cities; a poetry garden; and even a piece of the Berlin Wall. A PDF self-guided walking tour of the Seattle Center campus with more than twenty-five points of interest is available online at http://www.seattlecenter.com/tours.

There are five fountains on the grounds, the largest of which is the **International Fountain**. Found near the center of the Seattle Center grounds, northwest of the Space Needle, the International Fountain is active every day of the year. From a large silver dome, water shoots up to 120 feet high in changing patterns synchronized to music. The fountain is set in a 220-foot-diameter "bowl" surrounded by open space and lawn. On sunny days, the fountain attracts kids of all ages who try to run and touch the dome without getting sprayed. It is lit at night, with colored for holidays and special occasions. One of my favorite shots of the Space Needle is with the International Fountain in the foreground.

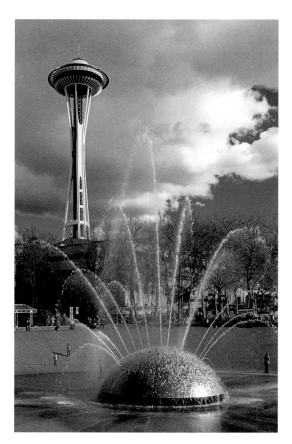

The Space Needle and International Fountain

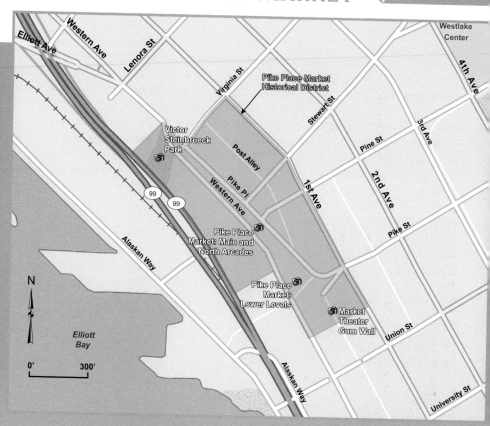

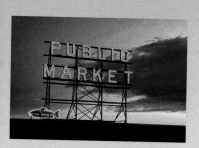

Sign marking the North Arcade entrance to the Pike Place Market

The Pike Place Market is another Seattle icon and one of the city's top tourist attractions. The market was opened in 1907 and has operated continually since then. It is filled with fun shops, restaurants, craft stalls, and produce and flower stands. It is famous for its fishmongers, vegetable and flower displays, street entertainers, and its neon signs.

Every nationally televised sports event from Seattle, it seems, is required to show a Pike Place Market scene, typically of the fishmongers throwing salmon.

The market is run by the quasi-governmental Pike Place Market Preservation and Development Authority (PDA). The PDA considers the Market to extend from 1st Avenue on the east to Western Avenue on the west, from Virginia Street on the north, to the middle of the block between Pike and Union Streets on the south—a total of 9 acres. These are also the boundaries of the "Pike Place Public Market Historic District" listed on the US National Register of Historic Places. The area encompasses many more buildings than the Main and North Arcades that front Pike Place (the two arcade buildings are what most people consider as "The Market"). The following segments describe particular places of interest in the general market, but the other market buildings beyond the Main and North Arcades present additional fun places to explore. If time permits on your visit to the market, these other buildings are well worth visiting.

Rachel the Pig, Main Arcade, Pike Place Market

Cost

There is no cost to enter any of the market buildings.

Contact

Website: www.pikeplacemarket.org. A walking tour guide and map is available from the website. Phone: 206.682.7453; email: info@pikeplacemarket.org.

Directions

The main entrance to Pike Place Market is at 1st Avenue and Pike Street in downtown Seattle. Pike Place, the street running through the market and that fronts the Main and North Arcades, is open to traffic but has very restricted parking. It is often crowded with pedestrians. The market's public parking garage is at 1531 Western Avenue, west of the Main Arcade. Parking rates in the official market garage are $3 per hour for the first four hours; lower "early bird" (before 9:30 a.m.) and evening (after 5:00 p.m.) rates are available. Other parking lots and street parking are available in the general market area.

Driving directions from northbound I-5:
To reach the Public Market Parking Garage, take the Madison Street Exit (#164A), and turn left. Follow Madison down the hill to Western Avenue. Turn right and follow Western five blocks to the garage (on the left). To reach the main market entrance instead of the garage, take the Seneca Street Exit, (#165), and veer left onto Seneca Street. Follow Seneca downhill to 1st Avenue and turn right. Follow 1st Avenue three blocks to Pike Street.

Driving directions from southbound I-5:
To reach the Public Market Parking Garage, take the James Street Exit (#165A). Merge onto 6th Avenue, then turn right onto Columbia Street, and continue downhill to Western Avenue. Turn left onto Western and drive seven blocks to the garage entrance on the left side of the street. To reach the main market entrance, take the Union Street Exit (#165B), turn right onto Union, after seven blocks turn right onto 1st Avenue and travel one block to Pike Street.

Pike Place Main Market (7 & 8)

The **Main and North Arcades** (7) form the heart of the market. These arcades are where most of the fresh produce, flowers, seafood, and meat are sold. Additionally, there are many artisan vendors selling crafts, souvenirs, and antiques. Essentially the vendor booths, stalls, and tables are set up along both sides of the arcades, forming a sensory feast of colors, textures, smells, sounds, and tastes (free samples are available from some of the vendors) of several blocks.

Except for the Desimone Bridge extension off the arcade,[1] the North Arcade is limited to the two rows of stalls and the pedestrian pathway between. The Main Arcade, however, contains many more shops on several levels below the arcade proper (there are also two levels above, but these are apartments). While not as colorful as the arcade, the **lower levels** (8) also present many fun opportunities worth exploring: many small shops specializing in imported goods, comics, jewelry, magic, and more; art galleries and studios; and one of my favorite spots, the Giant Shoe Museum.

The Main Arcade and its related shops on the lower levels form the Main Market. This is where you will find the most iconic market scenes. The main entrance is at the corner of Pike Street and Pike Place, under the famous public market neon sign and clock. This photogenic sign is best shot in the morning (to avoid bright western skies behind it), or even better, after sunset with the glow of the neon contrasting with a dark sky. At the main entrance is the market's unofficial mascot, Rachel the Pig—a life-size bronze piggy bank and a photo favorite with tourists. Rachel served as an inspiration for Pigs on Parade fundraisers in 2001 and 2007, when hundreds of pigs of various sizes, shapes, and colors were placed on display throughout the city. Many of those pigs can still be seen at other spots in the market and throughout downtown.

Also near the main entrance is one of several fishmongers in the market, the Pike Place Fish Market, made famous by its flying fish. There is typically a crowd around this fish stand, attracted by the fishmongers throwing fish and generally having fun with tourists (they like to attach the mouth of a large fish to a hidden wire, so they can pull the wire to suddenly open the fish's mouth when someone looks too closely). If you want photography of rows of seafood on display, you might try some of the several other seafood vendors in the market that are less popular. However, for flying fish and fishmongers playing around, this is the place (though, I must admit, I have yet to get a good image of a flying fish; the throws are fast and often unexpected).

The market area in and adjacent to the arcades is also great for people-watching, with or without a camera—from fishmongers to produce vendors, tourists to protestors, craftsmen to street performers. Most of the street entertainers perform on Pike Place just outside the arcades and are generally receptive to being photographed. Also out on Pike Place is another popular location, the original Starbucks. It is across from the northern end of the North Arcade at 1912 Pike Place.

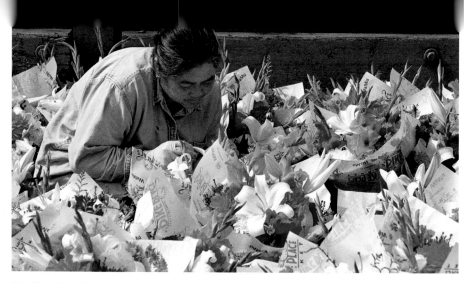

Pike Place Market is a great place for people watching, from flower vendors and fishmongers to street performers.

PHOTOGRAPHY TIPS

Though both arcades are partially open on the east along Pike Place, the light in the market is typically dim, requiring high ISOs or long exposures. Tripods are allowed, but discouraged by the PDA if there are crowds (which they usually are), and you may be asked to take your tripod down. However, I've had success using a tripod during busy times; you just need to be aware of other people and try not to impede foot traffic. Any lens from wide-angle to medium telephoto can come in handy—though carrying a lot of gear through the crowds can be problematic. Consider coming prior to opening for shots of vendors setting up and lighter crowds.

PHOTOGRAPHY RESTRICTIONS

There are no restrictions on non-commercial photography. An application and fees for commercial photography are required, though these are geared toward large commercial shoots and films. Fees vary based on size and impact of the production. The market's neon clock/sign is a registered trademark of the PDA.

Hours

Vendors within the market set their own hours, but are generally open daily, Monday–Saturday, 9:00 a.m.–6:00 p.m., and until 5:00 p.m. on Sunday. During peak farm seasons, produce vendors are often open by 7 or 8 a.m. Stores on the lower levels are typically open 10:00 a.m.–6:00 p.m. The market is closed on Thanksgiving and Christmas Day.

Location

The main entrance to Main Arcade is at Pike Street, west of 1st Avenue, where it turns into Pike Place. The North Arcade is directly north of the Main Arcade. From the parking garage (driving directions given on page 28), cross Western Avenue and take the elevator up to the market.

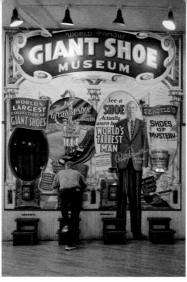

Flowers, Main Arcade

The Giant Shoe Museum, on the lower levels of the market, has several "peek holes" to view unusual shoes.

A sticky and ever-growing attaction — the Market Theater Gum Wall

Market Theater Gum Wall (9)

The **Market Theater Gum Wall** is one of Seattle's more "sticky" attractions. In Post Alley, flanking the ticket office to the Market Theater, below and south of the Main Arcade, the gum wall started collecting chewing gum in 1993. Initially, theater employees tried scraping the gum off the wall, but they eventually gave up, and gum in every color imaginable covered approximately 50 feet of brick wall, in some places up to 15 feet high and several inches thick. Occasionally, coins, rubber balls, or other small objects were embedded in the gum.[2] In early November 2015, the gum was cleaned for the first time in 20 years. Workers removed 2,350 pounds of gum in a 130-hour period. The wall did not stay bare long. A flash mob began regumming the wall with a peace symbol incorporating the Eiffel Tower in solidarity with France after the terrorist attack of November 13, 2015.[3] Besides making photographic images of how the mass of colorful gum covers the building, the site also makes for interesting, or perhaps disgusting depending on your point of view, close-up shots.

Directions
Address: 1428 Post Alley.
Walking directions from the Main Arcade: From the entrance to the Main Arcade at Pike Street and Pike Place, take the stairs south of Rachel the Pig down to Post Alley; alternatively, follow signs posted inside the market.

Victor Steinbrueck Park (10)

At the north end of the North Arcade, across Western Avenue, is **Victor Steinbrueck Park**. This 0.8-acre park has great views of Elliott Bay, the Seattle waterfront, and the Olympic Mountains, as well as a view of Mount Rainier over the city's football and baseball stadiums. This is a good place to view and photograph ferries as they ply Puget Sound, or container ships docking at the Port of Seattle. The park also contains two cedar totem poles. On sunny days, the park is usually popular with city residents of all types—joggers, businessmen and women, artists, and the homeless—and visitors alike, making it a good spot for people photography.

Hours
 Open, 6:00 a.m.–10 p.m., daily.

Directions
 Address: 2001 Western Avenue. The park is just north of the North Arcade of Pike Place Market where Pike Place intersects with Western Avenue and Virginia Street.

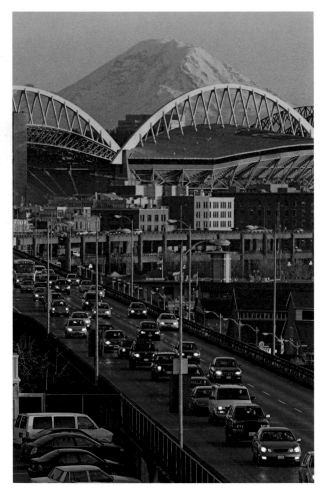

View of Mount Rainier from the Victor Steinbrueck Park

SEATTLE WATERFRONT

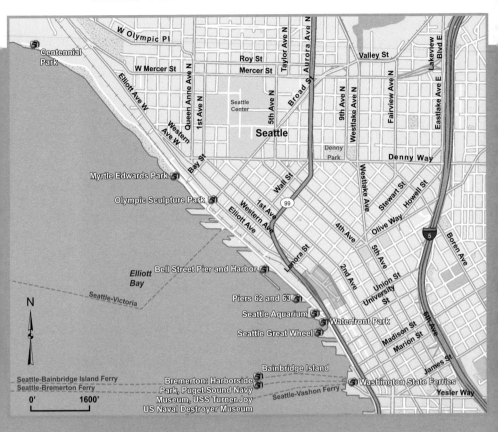

The Seattle waterfront stretches approximately
2.5 miles along Elliott Bay. The southern half,
known as the Central Waterfront, is developed
with shops, restaurants, and attractions along
Alaskan Way from the Colman Ferry Terminal in
the south to the Olympic Sculpture Park in the
north. Beyond the sculpture park, the waterfront
continues 1.2 miles through Myrtle Edwards Park.

The Central Waterfront is changing. Starting in 2013 and running through at least 2018, the Elliott Bay Seawall is being rebuilt in combination with the removal of the Alaskan Way Viaduct in a project known as Waterfront Seattle. This project will add a new surface street to the waterfront area along with new parks, paths, and access to the Elliott Bay waterfront.

The Central Waterfront is developed with a series of piers that extend into Elliott Bay. Piers 50 and 52 (there is no longer a Pier 51) are the location of the Seattle Ferry Terminal. Pier 52 is also known as the Colman Dock. The state's trademark white and green ferries provide passenger and vehicle service to Bainbridge Island and Bremerton from Colman Dock.

Just north of Colman Dock is Pier 53, home to Seattle Fire Station No. 5, which maintains two fire boats. Tours of one of the boats, the *Leschi*, are available on a limited basis (following the seawall reconstruction) by contacting the Seattle Fire Department.[1] Continuing north, you'll find Pier 54, home of Ivar's Acres of Clams, a locally famous seafood restaurant, and the Ye Olde Curiosity Shop. In addition to typical souvenirs, it maintains a number of odd curiosities including the "Sylvester" and "Sylvia" mummies, shrunken heads, fetal conjoined calves, totem poles, and other various Native American arts, narwhal tusks, and a walrus oosik.

Between Piers 55 and 56 is the home of Argosy Cruises, which offers a one-hour boat tour of Elliott Bay, a two-and-a-half-hour tour from the waterfront through the Hiram M. Chittenden Locks to Lake Union, and four-hour trip to Tillicum Village (a tourist attraction where visitors receive a Northwest Coastal Indian dinner) on Blake Island. If you purchase a CityPASS, you may want to take an Argosy Cruise, which is included on the pass, for the excellent views of the Seattle skyline. However, if you

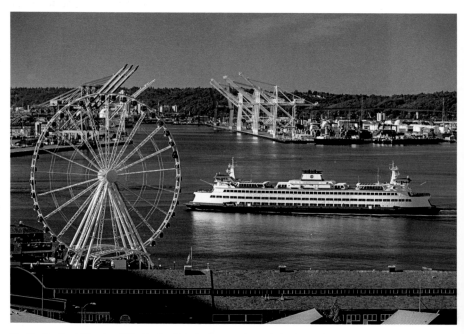

The Seattle Great Wheel and Washington State ferries—two top waterfront attractions

Seattle waterfront from inside the Seattle Great Wheel

did not purchase the pass, you can get essentially the same view from the deck of a Washington State Ferry for considerably less money. The best time of day for photographing the skyline from the water is late afternoon through sunset.

Continuing north, you'll find Pier 57 and the Seattle Great Wheel. The Great Wheel is a 175-foot Ferris wheel that opened in June 2012. Pier 58 is the site of Waterfront Park, a city-owned park with viewing platforms, tables and benches, a fountain, and a statue of Christopher Columbus. The view is of the waterfront and Elliott Bay, the Olympic Mountains, and (looking away from the water) the Seattle skyline. At the northern end of the park is one of the entrances to the Seattle Aquarium on Pier 59. The aquarium also occupies the former location of Piers 60 and 61, which were removed when the aquarium was built. North of the aquarium are Piers 62 and 63, which together form another Seattle city park. These two piers are conjoined (no opening between them), and are no longer covered, forming a large open space over the water with views in every direction.

Piers 64, 65, and 66 were removed in the mid-1990s and replaced with a new Pier 66 known as the Bell Street Pier and Bell Harbor Marina. Pier 67 is the location of the Edgewater Hotel. Pier 68 was removed when the hotel was built. Pier 69 is owned by the Port of Seattle and is the terminus for the *Victoria Clipper*—a passenger ferry that runs from Seattle to Victoria, British Columbia. Pier 70 is the final pier on the Central Waterfront and houses shops and restaurants. North beyond Pier 70 are the Olympic Sculpture Park and Myrtle Edwards Park.

The above overview suggests the wealth of scenic and photographic opportunities available on the Central Waterfront. Additional details on specific sites on the waterfront are given below.

Directions

Driving directions to reach the southern end of the waterfront from northbound I-5: Take the Dearborn Street/James Street/Madison Street off-ramp (Exit #164A) and follow the signs to exit at James Street. Turn left onto James Street, and after several blocks right onto Yesler Way. Yesler intersects Alaskan Way near the Colman Dock.

To reach the northern end of the waterfront from southbound I-5: Take Exit #166 to Eastlake Avenue E. Merge onto Eastlake and then veer almost immediately right onto Steward Street. A block later, turn right onto Denny Way. After passing the Seattle Center, turn left onto Warren Avenue and then left onto 1st Avenue. A block and a half later, turn right onto Broad Street, which curves into Alaskan Way at the Olympic Sculpture Park.

Washington State Ferries (11)

The State of Washington operates a fleet of twenty-two car and passenger ferries. Four car ferries and one passenger-only ferry ply the waters of Puget Sound from Colman Dock. The car ferries sail to Bainbridge Island and Bremerton, while the passenger-only vessel travels to Vashon Island. (This ferry is operated by King County rather than the state.)

The white and green Washington State Ferries are a Seattle icon, and no trip to Seattle is complete without a ferry ride, nor is any travel photography portfolio of the city complete without at least one image with a ferry. There are many vantage points from which you can view ferries and from which good ferry shots can be taken, both on and off the waterfront.

Additionally, the view of downtown Seattle from the ferries is spectacular. For the best views from a ferry, select either the Bainbridge Island or Bremerton runs, as these sail directly west from the Colman Dock and travel slower than the Vashon passenger-only ferry. Deciding which ferry to take is a personal choice. The crossing to Bremerton is longer (sixty minutes) than the one to Bainbridge (thirty-five minutes), but the Bainbridge boat sails twenty-three times per day versus fifteen for the Bremerton one. Also consider visiting some of the sights within walking distance of the ferry terminals in Bremerton and on Bainbridge (see pages 38 and 39).

Hours
The ferries to Bainbridge Island and Bremerton operate daily. Sailing times may be different on weekends and holidays and also vary with the season. Check www.wsdot.wa.gov/ferries/schedule for the current schedule.

Cost
As of 2015, the adult passenger fare for either the Bremerton or Bainbridge Island boats is $8. Passenger fares are round trip, and are collected westbound only (leaving Seattle). The standard vehicle and driver fare is $13.90 (less for small cars, more during peak season). Vehicle fares are one-way only.

Location
The Colman Ferry Terminal is on Pier 52 at 801 Alaskan Way near the southern end of the waterfront (driving directions on page 35).

Contact
Website: www.wsdot.wa.gov/ferries; phone: 888.808.7977 or 800.843.3779; email: wsinfo@wsdot.wa.gov.

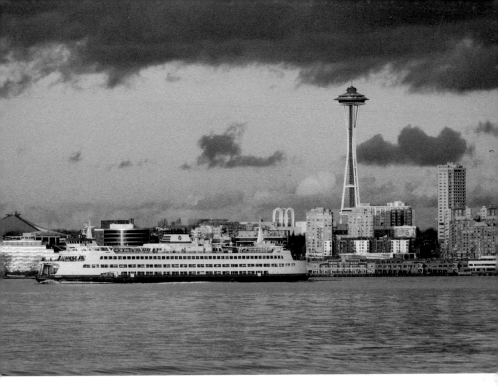

A Washington State ferry on Elliott Bay

PHOTOGRAPHY TIPS

There are several special considerations to remember when photographing from the ferries. Besides the movement of the boats through the water, the boats are constantly vibrating due to their running engines. Therefore, tripods are of little use. Also, you shouldn't rest the camera against any part of the ferry, as the engine vibrations are transmitted through the steel hull and superstructure. Select fast shutter speeds and appropriate ISOs for the light conditions. The best light on downtown Seattle for shooting from a ferry is in the late afternoon through sunset. A possible itinerary might be to board a mid-day sailing, spend some time in Bremerton or on Bainbridge, and then catch a ferry back to the city so you arrive about sunset.

PHOTOGRAPHY RESTRICTIONS

Contrary to popular belief, there are no restrictions on photographing on Washington State Ferries within the publicly accessible areas of the ships.

Bainbridge Island (12)

Though not on the Seattle waterfront, nor even in Seattle, Bainbridge Island and Bremerton are included here because they are just a walk (and a ferry ride) away. **Bainbridge Island** is directly west of Seattle, a thirty-five-minute ferry ride from the Seattle waterfront. Though the city of Bainbridge Island incorporates the entire island and has several sites of photographic interest, the downtown area, Winslow,[2] where the ferries land, is the focus here. Though officially a city, Bainbridge Island is radically different from Seattle, with a population density of less than 850 people per square mile (compared to over 7,250 in Seattle).[3] Winslow is the "big" population center on the island, but rather than a city feel, it has the air of a small town. Most of Winslow is within walking distance of the ferry terminal.

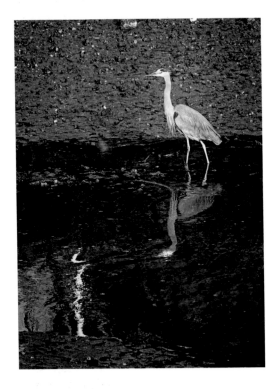

Great blue heron along the waterfront on Bainbridge Island

There are no must-see sights here; instead, it's simply a pleasant place to walk around;[4] a place to enjoy a small island town. There are several winery tasting rooms, various small shops and eateries, a number of antique stores, and a waterfront area. The main street is Winslow Way, just a short walk from the ferry terminal. This is where most of the shops and stores are. There's a farmers' market at Town Square at City Hall Park (one block north of Winslow Way on Madrone Lane) on Saturday mornings, mid-April through mid-December. It is distinctly different from the hustle and bustle of Pike Place Market in Seattle. To see the waterfront, again distinctly different than Seattle's, be sure to check out the City Dock and Waterfront Park on Eagle Harbor, several blocks south of Winslow Way.

Bremerton (13–15)

Bremerton is the largest city on the Olympic peninsula and a distinctly different look and feel than Winslow and Bainbridge Island (as well as Seattle). This city grew up around the Puget Sound Naval Shipyard and is a naval town to this day. Bremerton is southwest of Bainbridge Island, on Sinclair Inlet. The ferry from Seattle sails around the southern end of Bainbridge Island and through Rich Passage on its sixty-minute trip to Bremerton.

There are several attractions within walking distance of the ferry terminal in Bremerton. Immediately adjacent, west of the ferry terminal, is the delightful **Harborside Fountain Park** (13). This park features five copper-ringed fountains whose shapes are reminiscent of steamship smokestacks or submarine conning towers. In fact, the northern end of the park actually has a submarine conning tower poking out of the ground, so you can compare it to the fountains if you wish. The park also provides great views of the ferries as they come in to land at Bremerton.

The **Puget Sound Navy Museum** (14) is at the park. The museum, one of twelve administered by the US Navy, presents and interprets the naval history of the Pacific Northwest. Permanent exhibits include experiencing life as a sailor aboard a nuclear aircraft carrier and learning why submarines are perfect for carrying out special operations.

East of the ferry terminal is the Louis Mentor Boardwalk along the waterfront, which leads to the **USS *Turner Joy* U.S. Naval Destroyer Museum Ship** (15), a Vietnam War-era destroyer. A self-guided tour through the ship is available, providing good photo opportunities both on and off the ship.

Hours
Puget Sound Navy Museum: Open daily, 10:00 a.m.–4:00 p.m., but closed Tuesdays, October–April.

USS *Turner Joy* Museum Ship: Open daily, March 1–the 3rd Sunday in October, 10:00 a.m.–5:00 p.m. Open Wednesday–Sunday, 10:00 a.m.–4:00 p.m. (weather permitting), November 1–February 28. Closed Thanksgiving, Christmas, New Year's Day, and Easter Sunday. Ticket sales stop a half-hour prior to closing.

Cost
Puget Sound Navy Museum: free admission.

USS *Turner Joy* Museum Ship: adults $14; free for active military

Contact
Puget Sound Navy Museum website: www.pugetsoundnavymuseum.org; phone: 360.479.7447.

USS *Turner Joy* Museum Ship website: www.ussturnerjoy.org; phone: 360.792.2457; email: dd951@sinclair.net.

Location and directions
Harborside Fountain Park is adjacent to and left (west) of the ferry terminal. The Puget Sound Navy Museum is at the north end of the park. To reach the USS *Turner Joy* Museum Ship from the ferry terminal, turn right and walk along the waterfront walkway past the marina to the ship.

PHOTOGRAPHY RESTRICTIONS

Neither museum has photography restrictions. However, on the Turner Joy, *visitors walk through hatches and climb 70-degree ladders. Large backpacks are discouraged.*

Harborside Fountain Park is adjacent to the ferry terminal in Bremerton.

Seattle Great Wheel (16)

On Pier 57, the **Seattle Great Wheel** is one of the city's newest attractions. One of the tallest Ferris wheels in the United States, the Great Wheel consists of a 175-foot wheel with forty-two climate-controlled gondolas (forty-one standard and one VIP gondolas). The ride includes three trips around the wheel and lasts approximately ten to twenty minutes depending on time of year, how large the crowd is, and how many gondolas are being loaded. The standard gondolas seat eight adults. The staff tries to seat individual parties together, but cannot guarantee it for parties of six or less if there are long lines.

There is one VIP gondola available with four leather bucket seats, a stereo system, and a glass floor. VIP riders also receive a special t-shirt, a champagne toast at the restaurant next door, photo booth photos, an exclusive ride for your party in the gondola, and no waiting in line (unless other VIP riders are present).

The Seattle Great Wheel is built right over the water. It is on the end of the pier and actually extends almost 40 feet beyond the pier's edge. As you might imagine, great views of the waterfront, Elliott Bay, ferries, and the Seattle skyline are to be had by riding the Great Wheel.

PHOTOGRAPHY TIPS

Though the area around the wheel is somewhat restricted (by the fact that it is on a pier), by using a wide-angle to short telephoto lens, interesting compositions can be made with the wheel from its base. When shooting from inside a gondola, you might wish to use a polarizer to help minimize reflections and/or shoot with the lens as close to the glass as possible. As the gondolas have tinted glass, you may have to increase your ISO setting, particularly if using a polarizer. You may also want to have something to clean the glass with (I used a shirt sleeve on my last ride), as the way the seats are oriented in the gondolas, the back of riders' heads tend to leave oily marks on the glass.

For a good view of the wheel with the city in the background, you need to get out on Elliott Bay—a ferry is a good option. There is also a good view from the end of Piers 62 and 63. This view is particularly good at night when the wheel is lit and spinning. From Piers 62/63 you can shoot a long exposure with a tripod, capturing the motion of the wheel (such a shot is not typically possible from a boat or ferry). However, the piers are not totally steady and can move with wave action. So to ensure a sharp image, try to keep night exposures reasonably short and consider shooting additional exposures.

Hours

The Great Wheel's hours vary seasonally. From July through September, it opens at 10:00 a.m. and closes at 11:00 p.m. except for Friday and Saturday when it closes at midnight. The rest of the year, it opens at 11:00 a.m., Monday– Friday, and at 10:00 a.m., Saturday and Sunday. It closes at 10 p.m. Sunday–Thursday and at midnight on Friday and Saturday.

Seattle Great Wheel with its climate-controlled gondolas

Cost
Adult tickets $13; VIP tickets $50

Contact
Website: www.seattlegreatwheel.com;
phone: 206.623.8607; email: greatwheel@
pier57seattle.com.

Location
1301 Alaskan Way on Pier 57, a few
blocks north of Colman Dock (see driving
directions on page 35).

Waterfront Park (17)

The area between Piers 57 and 59 is **Waterfront Park**, which has excellent views of Elliott Bay, the Seattle Great Wheel, the Olympic Mountains, and passing ferries. There is also a view of the city skyline, though there are better skyline viewpoints elsewhere on the waterfront. The park also contains a bronze fountain and an unusual statue of Christopher Columbus.

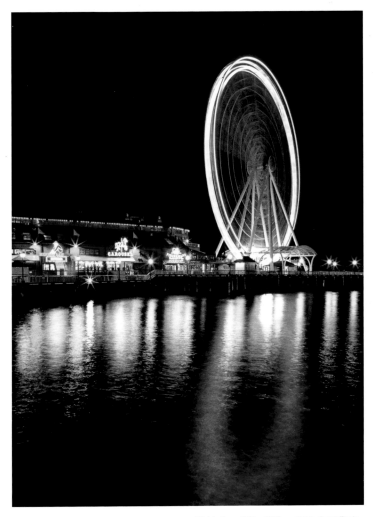

Night view of Pier 57 from Waterfront Park

Hours
Open daily, 6:00 a.m. to 10 p.m.

Location
1301 Alaskan Way, just north of Pier 57
(see driving directions to the waterfront,
page 35).

The **Seattle Aquarium** is one of the top attractions in the city. The aquarium spans two buildings, the pier shed on Pier 59 and a two-level building just north of the pier. Exhibits fill perhaps two-thirds of the Pier 59 building, which also houses the aquarium's administrative offices.

The entrance is along Alaska Way at the front of the Pier 59 building. After passing the ticket booth, visitors are greeted by the two-story tall "Window on Washington Waters." This 120,000-gallon tank is filled with more than 800 local fish and other sea creatures. Three times a day (10:00 a.m., 11:30 a.m. and 12:15 p.m.), divers enter the tank and interact with aquarium visitors, answering questions via special diving masks.

Next, visitors pass a wave exhibit to the *Life on the Edge* exhibit, a series of tide pools where touching is encouraged. Nearby is the *Life of a Drifter* exhibit featuring giant Pacific octopi and moon jellies. In the back of the building are the *Pacific Coral Reef* exhibit, with a large variety of tropical fish, and the *Tropical Pacific* exhibit, which features unusual creatures from the Pacific Ocean.

The main entrance to the second building leads to a shore birds exhibit. Much of this exhibit is open, allowing photography of the birds without nets or glass between you and the birds. Birds in the exhibit include tufted puffins, long-billed curlews, black oystercatchers, rhinoceros auklets, and more. Continuing onward and downward into the building leads to a Puget Sound fish exhibit and the Underwater Dome, which provides a 360-degree view of local sea life including salmon, ling cod, sturgeon, and skates. For a special treat, be there at 1:30 p.m. daily when the fish are fed. Most of the rest of the aquarium is dedicated to marine mammals (with both under- and above-water viewing) including sea and river otters, and harbor and northern fur seals.

PHOTOGRAPHY TIPS

My favorite exhibits for photography are the octopi, the Pacific coral reef, the shore birds, the Puget Sound fish, and the underwater dome. Tripods are allowed, though the staff asks photographers not to block other visitors. Flash is allowed in most exhibits. Many of the tanks have dim lighting and fast-moving fish, so using a high ISO setting or a flash is recommended. If using a flash, hold it off camera to avoid reflections off the tank glass. Since much of the photography is through glass or plexiglass, having a cleaning cloth to remove fingerprints and smudges is also useful. The aquarium is very popular with children, so I suggest going early or on a weekday to avoid crowds.

PHOTOGRAPHY RESTRICTIONS

Flash is allowed except where noted. Tripods are allowed, but care should be taken not to block other visitors.

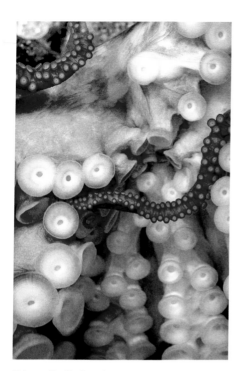

Octopus, Seattle Aquarium

Hours

Open daily, 9:30 a.m.–6:00 p.m., but the ticket office closes at 5:00 p.m. Select days in the summer have extended hours to 7:00 p.m.

Cost

Adult tickets, $22.95. The aquarium is also part of the CityPASS and also has an admission combined with an Argosy harbor cruise for $40.

Contact

Website: www.seattleaquarium.org; email: contactus@seattleaquarium.org; phone: 206.386.4300.

Location

1483 Alaskan Way on Pier 59; it is near the middle of the waterfront (see driving directions on page 35).

Piers 62 & 63 (19)

Piers 62 and 63 together form a Seattle city park. Unlike most of the other piers on the waterfront, there are no permanent buildings or structures on Piers 62 and 63; instead it is simply a large open space set over the water. Without a specific attraction, the pier can be a calm oasis amidst the normal bustle of the waterfront. The name of the game here is views: views of Elliott Bay, the Olympic Mountains, Mount Rainier, ships and ferries, the Great Wheel, and the Seattle skyline. When photographing the skyline, it's likely the Alaska Way Viaduct (an elevated highway just east of Alaskan Way that is not particularly photogenic) will be in your composition, at least until it is torn down sometime in the next few years.[5] Because Piers 62 and 63 stick farther out in the water than Waterfront Park (south of the aquarium), the Seattle skyline view is better here and the viaduct is less noticeable. In the future, the view of skyline will improve, after the viaduct is replaced by a tunnel.

Hours

Open daily, 6:00 a.m.–10 p.m.

Location

1951 Alaskan Way, just north of the Seattle Aquarium (see driving directions on page 35).

Bell Street Pier and Harbor (20)

The **Bell Street Pier and Harbor**, at Pier 66, is the cruise ship terminal and a small-boat marina and harbor. The pier also has several restaurants. The view of downtown Seattle with Bell Harbor in the foreground is one of my favorites on the waterfront. Late afternoon through sunset, when the western sun shines on the city, is the best time for photographing this location. Besides views from the street and dock level, there is a rooftop-plaza viewpoint, providing one of the few views on the waterfront above street level. A footbridge over Alaska Way provides an additional viewpoint. The footbridge connects the pier to a parking garage and the Belltown area of downtown Seattle.

Location
2203 Alaskan Way near the northern end of the waterfront (driving directions on page 35).

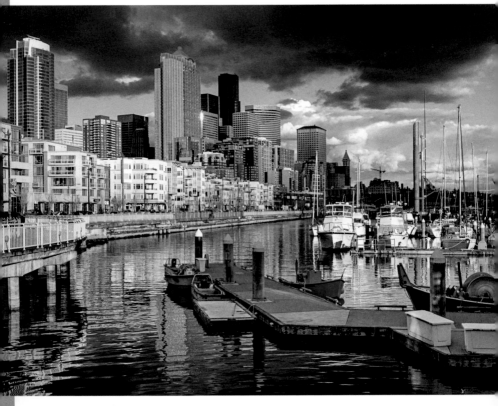

Bell Street Pier and Harbor

Olympic Sculpture Park (21)

At the northern end of the Central Waterfront lies the **Olympic Sculpture Park**. Part of the Seattle Art Museum, the 8.5-acre park currently holds twenty semi-permanent outdoor sculptures as well as temporary displays in the park's PACCAR pavilion. Plans call for the sculptures to be rotated out, with new pieces added over time. With art, gardens, and views of the Space Needle, Elliott Bay, the Olympic Mountains, and downtown Seattle, this park is a change of pace from the normal waterfront experience.

A Z-shaped, wheelchair-accessible path winds through the park from the waterfront to the PACCAR pavilion. Most of the major pieces can be viewed from this path, but other shorter, smaller trails lead to other pieces. Free public tours of the park and art installations are available on a regular basis. Tour topics vary throughout the year, as do the start times. The tours normally are an hour long. Private tours are also available for a fee.

Though many of the sculptures are fun to photograph, my favorite piece is *Eagle*, by Alexander Calder. This large, orange, arched sculpture sits on a rise overlooking Elliott Bay and can be used to frame ferries or ships by looking west or the Space Needle by looking east.

Hours

The park is open daily thirty minutes before sunrise to thirty minutes after sunset. The PACCAR Pavilion is open March through October, Tuesday–Sunday, 10:00 a.m.–5:00 p.m., but only on weekends the rest of the year, closing at 4:00 p.m. The pavilion is closed on most major holidays.

Contact

Website: http://www.seattleartmuseum.org/visit/olympic-sculpture-park; phone: 206.654.3100.

Location

2901 Western Avenue; north of Broad Street between the water and Western Avenue. Pay parking is available in the PACCAR Pavilion garage at the southeast corner of Broad Street and Western Avenue. Follow the directions on page 35 to the northern end of the waterfront.

Entrance to the Olympic Sculpture Park

PHOTOGRAPHY RESTRICTIONS

Commercial photography prohibited. Individual artworks are copyrighted material, and non-personal use of photographs containing images of the sculptures may be restricted.

Myrtle Edwards and Centennial Parks (22 & 23)

Stretching along Elliott Bay from the Olympic Sculpture Park almost to the base of Magnolia Hill is **Myrtle Edwards Park** (22). A 1.25-mile paved trail runs through the park, which is well used by local walkers, joggers, and bicyclists. The park has views of downtown Seattle, Puget Sound, the Port of Seattle, the Olympic Mountains, and Mount Rainier. The park provides a waterfront experience without all the commercialism of shops and restaurants.

The northern end of the park adjoins **Centennial Park** (23), also known as Elliott Bay Park. Centennial Park, operated by the Port of Seattle, is at Pier 86. The park has a fishing pier with a tackle shop and a rose garden, and provides close-up views of grain ships and grain-terminal operations.

PHOTOGRAPHY TIPS

From the fishing dock, an interesting shot can be made of the downtown skyline framed by the grain-ship terminal. Or, by using a telephoto lens, you can capture the skyline without the grain terminal by shooting through the terminal's opening. Either way, the view of the skyline from this point is relatively unique, compressing the entire waterfront side of downtown, from the Post-Intelligencer *globe[6] to the Smith Tower, in a single frame. Using a telephoto lens, you can compose Mount Rainier towering over the giant container ship cranes at the port, with or without riders, walkers, or joggers in the foreground.*

Hours

Myrtle Edwards Park is open twenty-four hours a day. Centennial Park is open daily, 6:00 a.m.–11:00 p.m.

Location

The southern end of Myrtle Edwards Park is at 3130 Alaskan Way. Follow the directions on page 35 to the northern end of the waterfront. Centennial Park is at Pier 86. **Driving directions from I-5:** take the Mercer Street Exit (#167) and follow Mercer 1.6 miles to Elliott Avenue W. Turn right on Elliott and in about 0.4 miles, take the exit ramp on the right toward Amgen Ct W and the Magnolia Bridge. On the exit ramp, take the left lane toward Piers 86–91. After crossing over Elliott Avenue, turn right on Alaskan Way and drive 0.5 miles to the Centennial Park parking lot.

View of downtown Seattle from Centennial Park

NORTH DOWNTOWN SEATTLE

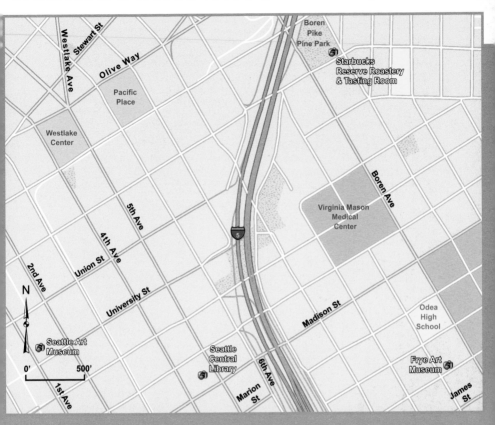

Outside of the major downtown attractions already described, Seattle, as a modern American city, has many scenic and photographic opportunities. There are historic and modern examples of architecture, many museums, an urban shopping mall, interesting street scenes, and, of course, plenty of interesting people. Many fine photographs can be made by just roaming the streets. However, to give you more focus, I've suggested a few locations here.

Dome of the former First United Methodist Church in downtown Seattle

I've divided these downtown attractions into two groups, those in the northern half of downtown and those in the southern half. Admittedly, the division between north and south is somewhat arbitrary. However, the listed southern downtown attractions are mostly within easy walking distance of each other, and make a fine walking tour[1], while those in the north do not. Of course, other walking options are possible—for example, the Seattle Art Museum is within easy walking distance of Pike Place Market, the Seattle Public Library and the Frye Art Museum are close to the Sky View Observatory, and a walking visit to the International District and Pioneer Square could easily be extended to the Central Waterfront.

Cars reflected on the Seattle Central Library

Seattle Art Museum (24)

The Seattle Art Museum, also known as SAM, has three locations: the Olympic Sculpture Park described on page 47, the main museum downtown a few blocks south of the Pike Place Market, and the Seattle Asian Art Museum in Volunteer Park (see page 86). The downtown museum displays African, American, ancient Mediterranean, Asian, contemporary and modern, European, Islamic, Native American, Pacific Northwestern, and Oceanic pieces from their large collection, as well as special exhibitions. Recent special exhibitions have featured Picasso, ancient Peruvian art, European masters, and American art masterworks. Museum visitors are greeted by Jonathan Borofsky's 48-foot-tall, kinetic *Hammering Man* sculpture just outside the main entrance.

Tours are free with museum admission. Tour topics and times vary throughout the year, but include local artists discussing their favorite works, in-depth "In-focus" talks dedicated to a single gallery, and tours of the special exhibitions. Tours are typically thirty to sixty minutes long. Private tours are also available for an extra fee.

PHOTOGRAPHY RESTRICTIONS

Photography is allowed for personal, non-commercial purposes except in a few select galleries and selected art pieces marked with a "no photography" symbol. Tripods, "selfie sticks," flash photography, and video cameras are prohibited.

Hours

The Seattle Art Museum is closed Tuesdays and on Thanksgiving and Christmas. Otherwise, it opens at 10:00 a.m. and closes at 5:00 p.m. except on Thursday when it closes at 9:00 p.m.

Cost

Adult tickets, including access to all collections and special exhibitions, are $19.95. For access excluding special exhibitions, a donation is requested. Thursdays are free, except for a $12 adult surcharge for special exhibitions.

Contact

Website: www.seattleartmuseum.org/visit/seattle-art-museum; phone: 206.654.3100.

Location and Directions

Address: The Seattle Art Museum is at 1300 1st Avenue.
Driving directions from northbound I-5: Take the Seneca Street Exit (#165) and drive down the hill to 1st Avenue. Turn right and SAM will be one block ahead on the right. **From southbound I-5:** Take Exit #165B to Union Street, drive downhill to 1st Avenue and turn left. SAM will be on your left. Parking is available at the Russell Investment Center Garage (enter off Union Street). Parking discounts are available on weekends by requesting a voucher at the SAM ticketing desk.

Starbucks Reserve Roastery and Tasting Room (25)

It may be debatable whether Seattle is the coffee capital of the world, but it certainly is coffee central in the United States. It's also debatable how many coffee shops there are in Seattle. DiscoverAmerica.com says there are 2.5 for every 1,000 residents. A Google search for Starbucks in Seattle returns 180 Starbucks shops alone,[2] and there are many, many other coffee shops. But Starbucks is what originally put Seattle on the coffee map.

In 2014, Starbucks opened their crown jewel—the **Starbucks Reserve Roastery and Tasting Room**. If you are a coffee lover, a trip to Seattle is not complete without a visit to the Starbucks Roastery. This is not your typical coffee shop. The Roastery is 15,600 square feet on two levels with seventeen- to twenty-foot-high ceilings and the space is filled with copper, chrome, and teak. There are two large roasters, a coffee library with more than 200 books on the beverage, a coffee experience bar, and plenty of lounge and bar seating. It is staffed by dozens of baristas serving select coffees from around the world.

Part of a coffee silo in the espresso bar at the Starbucks Reserve Roastery and Tasting Room

Hours
Open daily, 6:30 a.m.–11:00 p.m.

Contact
Website: http://roastery.starbucks.com; phone: 206.624.0173.

Location and Directions
Address: 1124 Pike Street.
Driving directions from northbound I-5: Take the Olive Way Exit (#166) and merge onto Olive Way. A block later, turn right on Melrose Avenue. After two blocks, the Starbucks Roastery will be on your right.
From southbound I-5: Take Exit #165B to Union Street, turn right onto 7th Avenue and one block later, right onto Pike Street. The Roastery will be on your left after five blocks. There is no dedicated parking for the Roastery, so park on the street or in one of several parking lots in the area.

Frye Art Museum (26)

The **Frye Art Museum** displays the collection of Charles and Emma Frye, who willed it to the people of Seattle in perpetuity with the stipulation that admission be free. The museum includes 232 paintings in the Frye Founding Collection, which mainly contains late nineteenth- and early twentieth-century German art, as well as many other paintings purchased or gifted to the museum following its establishment in 1952. Many of these additional works are from late nineteenth- and early twentieth-centuryAmerican painters. In addition, the museum offers special exhibitions. Recent special exhibitions included photography by Andy Warhol and one that brought together the works of Isamu Noguchi and Qi Baishi.

Free tours of the exhibitions are available every day at 1:00 p.m. and Tuesdays, Saturdays, and Sundays at 11:30 a.m. Private tours are also available.

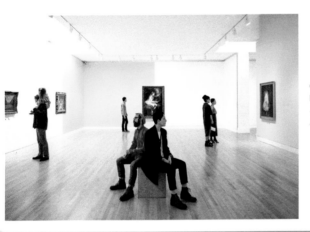

Gallery inside the Frye Art Museum, *photo by Megumi Shauna Arai, courtesy of Frye Art Museum*

PHOTOGRAPHY RESTRICTIONS

Photography is allowed in many areas of the museum for personal, non-commercial purposes except in certain temporary exhibits. Tripods, monopods, flash photography, and video cameras are not permitted.

Hours
Open Tuesday–Sunday, 11:00 a.m.–5:00 p.m., except Thursday, when it closes at 7:00 p.m.

Contact
Website: http://fryemuseum.org; phone: 206.622.9250; email: info@fryemuseum.org.

Location and Directions
Address: 704 Terry Avenue.
Driving directions from northbound I-5: Take Exit #164A for James Street, continue straight to Cherry Street, and turn right. In three blocks, turn left onto Terry Avenue. **From southbound I-5:** Take the James Street Exit (#165A) and merge onto 6th Avenue. Turn left on Cherry Street and four blocks later, turn left onto Terry Avenue. The Frye will be on your right.

Seattle Central Library (27)

Seattle has its share of modern architecture, but the Seattle Central Library is special. At eleven stories tall, it is dwarfed by many of the buildings around it, yet it is truly unique and a pleasure to photograph. The library is not just a tall box, like many downtown buildings. As the library's website notes, the building was designed by award-winning Dutch architect Rem Koolhaas, in a joint venture with Seattle-based LMN Architects: "The eleven-floor building contains an innovative 'Books Spiral,' which allows patrons unprecedented access to the Library collection. The crystalline steel-and-glass structure contains five platforms — each devoted to a specific program cluster." There are two Seattle structures listed in the top 150 favorite structures in the United States by the American Institute of Architects (compiled in 2007): Safeco Field and the Seattle Central Library.

PHOTOGRAPHY TIPS

Both the inside and outside of the library present many photographic opportunities for great abstract shots. With its glass exterior, it also presents opportunities for unusual reflections. I like capturing colorful, abstract reflections of yellow and orange taxi cabs and other colorful cars in the glass. Much of the inside of the library is brightly painted, providing color to your abstract work. If you photograph inside, be sure to check out the fourth floor, which is painted totally in red. Be warned, however; this area is very dark, making photography without a tripod a challenge.

PHOTOGRAPHY RESTRICTIONS

Inside the library, tripods and lighting equipment are not allowed without a permit. Library staff members may ask photographers to stop or leave if they appear to be interfering with library operations. However, if you are not obstructing other patrons, the staff is very friendly and helpful, even suggesting places to photograph. Commercial photography inside the library requires a permit. Permits, both for tripods and/or commercial work, are available for a donation of $50 to $300 depending on scope. Commercial photography also requires proof of liability insurance. For a permit, contact event services.

Hours

Generally open Monday–Thursday, 10:00 a.m.–8:00 p.m.; Friday and Saturday,10:00 a.m.–6:00 p.m.; and Sunday, noon–6:00 p.m. Closed on major holidays and occasionally other days due to budget cuts and in-service days (check the website for details).

Contact

Website: www.spl.org/locations/central-library; general phone: 206.386.4636; for commercial photography permits, call and ask for event services.

Location and Directions

Address: 1000 4th Avenue.
Directions from northbound I-5: Take Exit #164A (Dearborn/James/Madison Streets), then take the Madison Street/ Convention Place exit, and turn left on Madison Street; the library is on the right (between 5th and 4th Avenues) after two blocks. To park underneath the library, continue to 4th Avenue and turn right; after one block turn right on Spring Street, and then right again into the library garage entrance. Parking can also be found on the street or in many nearby lots and parking garages.
From southbound I-5: Take Exit #165A toward James Street and merge onto 6th Avenue, then turn right onto Columbia Street, and right again onto 4th Avenue.

A portion of the Seattle Central Library with a high-rise office building in the background

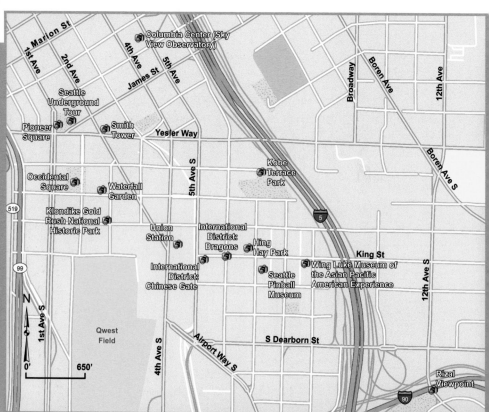

Columbia Center (Sky View Observatory)

Marion St
1st Ave
2nd Ave
4th Ave
5th Ave
James St
Broadway
Boren Ave
12th Ave

Seattle Underground Tour

Yesler Way

Pioneer Square
Smith Tower

Boren Ave S

Occidental Square
Waterfall Garden
Kobe Terrace Park

5th Ave S

519

Klondike Gold Rush National Historic Park

Union Station

International District: Dragons
Hing Hay Park

King St

99

International District: Chinese Gate
Seattle Pinball Museum
Wing Luke Museum of the Asian Pacific American Experience

12th Ave S

I-5

N

1st Ave S

Qwest Field

4th Ave S
Airport Way S
S Dearborn St

0' 650'

Rizal Viewpoint

90

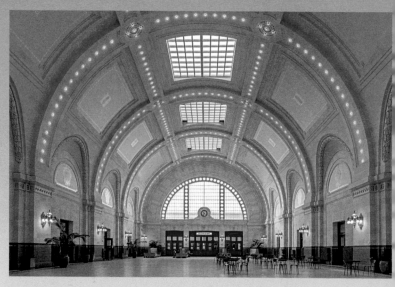

The Grand Hall, Union Station

Columbia Center and Smith Tower (28 & 29)

While Seattle has its share of skyscrapers, two stand out. One, because it is the tallest building in Seattle (and currently, the fourth tallest building in the United States west of the Mississippi) and the second because, when it was built, it was the tallest building in the world outside New York City. The seventy-six-story **Columbia Center** (28), also known as the Columbia Tower, is 943 feet tall and offers a commanding view of Seattle and its surroundings. For a bird's-eye view that stretches from Mount Bachelor in Canada through the Olympic Mountains to Mount Rainier and east to the Cascade Mountains, the Sky View Observatory on the seventy-third floor is as high as the public can climb in the city. Reportedly, the observatory is the tallest public viewpoint on the West Coast. Unfortunately, it does not offer a 360-degree view, but only 270 degrees (there is no view to the north-northeast). Also, the view is through windows.

PHOTOGRAPHY TIPS

When photographing from the Sky View Observatory, to help cut reflections, try using a polarizing filter and placing your lens close to the glass.

The **Smith Tower** (29) was completed in 1914 and was the tallest office building west of the Mississippi until 1931. At thirty-eight floors and 489 feet tall, it remained the tallest building on the West Coast until the construction of the Space Needle in 1962. The observation deck is on the thirty-fifth floor. While much lower than the Sky View Observatory, the Smith Tower Observation Deck is open to the air and wraps completely around the building. It is also nearer the waterfront than the Columbia Tower, providing closer views of ferries and other waterfront features. I particularly like the view from the northwest corner of the observation deck down 2nd Avenue with tall office buildings framing the Space Needle. In addition to this view, a visit to the Smith Tower offers a more historical feel than the Columbia Tower. The observation deck and adjoining Chinese Room are accessed via the last manually operated elevators on the West Coast.

In early 2015, the Smith Tower was purchased by new owners. They are upgrading much of the building including the observation deck and Chinese Room. During the renovations, the observation deck and Chinese Room were closed to the public. The scheduled reopening will be sometime in 2016. Before planning a visit, be sure to contact the Smith Tower for the current status.

PHOTOGRAPHY TIPS

While I like being able to photograph from outside (instead of behind glass as at the Columbia Tower), the Smith Tower observation deck is relatively narrow, and if busy, it may be impossible to use a tripod due to space limitations. The observation deck is also wrapped in by a tall metal fence. Luckily, the spaces in the fence are large enough to poke a lens through.

View from the Smith Tower looking downward toward Pioneer Square

Location and Directions

Columbia Center address: 701 5th Avenue.

Directions from northbound I-5: Take the Seneca Street Exit (#165, left off freeway) onto Seneca Street and turn left onto 5th Avenue; the Columbia Center is four blocks south on the right.

From southbound I-5: Take Exit #165A toward James Street, merge onto 6th Avenue, turn right onto Columbia Street and left on 5th Avenue; Columbia Center will be on the right. Parking is available beneath the building, on the street, or in nearby lots and garages.

To reach the Sky View Observatory, go to the main lobby on the fourth floor of Columbia Center. Find the elevator bank labeled for floors 36–76, and take an elevator to the fortieth floor. Find a second set of elevators labeled for floors 66–76 and take one to the seventy-third floor.

Smith Tower address: 506 2nd Avenue.

Directions from northbound I-5: Take Exit #164A (Dearborn/James/Madison Streets), exit at James Street, and turn left on James Street. The Smith Tower is five blocks ahead at 2nd Avenue.

From southbound I-5: Take Exit #165A James Street and merge onto 6th Avenue, at James Street turn right and continue to 2nd Avenue. Parking is available on the street or in nearby lots and garages.

Walking directions from the Columbia Center: From the 5th Avenue entrance to the Columbia Tower, go south on 5th Avenue one and a half blocks to James Street. Turn right on James Street and walk three blocks to 2nd Avenue.

Hours

The Sky View Observatory is open daily, 9 a.m.–10 p.m. The Smith Tower Observation Deck and Chinese Room were recently closed for renovations. For the new hours and to be sure the observation deck is open before visiting, contact the Smith Tower.

Cost

Adult tickets are $14.25 for the Sky View Observatory. When open, a ticket to the Smith Tower Observation Deck was $7.50; the price is likely to be different when it re-opens.

Contact

Sky View Observatory website: www.skyviewobservatory.com; phone: 206.386.5564; email: ccskyview@gmail.com. Smith Tower Observation Deck website: www.smithtower.com; phone: 206.622.4004; email: info@smithtower.com.

Pioneer Square (30–34)

Pioneer Square is now a neighborhood on the southwestern corner of downtown, but originally it was the center of the city. Building began in the district in 1852, though not much survives from the mid-1800s because of the Great Seattle Fire of 1889. The area was rebuilt in the 1890s, and today the district is characterized by late nineteenth-century brick and stone buildings of Romanesque revival architecture. The concentration of late-nineteenth-century buildings gives the district a lot of appeal. The district is generally west of Alaskan Way S to 5th Avenue S on the east, from S King Street on the south to one to two blocks north of Yesler Way.[1] Most of the district is part of the Pioneer Square-Skid Road Historic District and is listed on the National Register of Historic Places. Parts of the district still have a "skid-road" feel, and many people prefer not to walk alone in the area.

The district is named for **Pioneer Square** (30), which is actually a triangular-shape plaza at the corner of Yesler Way and 1st Avenue. The Square is home to the famous picturesque Victorian pergola dating from 1909, as well as a Tlingit totem pole from 1938. The **Seattle Underground Tour** (31) also leaves from this location. The underground tour lasts about sixty to seventy-five minutes. For the first portion of the tour, patrons are seated in a restored saloon and hear a talk about Seattle's history. From there, the tour breaks into smaller groups for a walking tour of approximately three city blocks. It's a good way to learn some of Seattle's history, but being with a group, you probably won't have much time to do serious photography. Overall the tour gets mixed reviews; on Yelp, it averages a 3.5 star rating (out of 5).

A lush oasis in downtown Seattle—the Waterfall Garden

A block east and south (between S Washington and S Main Streets along Occidental Avenue S) is **Occidental Square** (32), a shady park in the center of Seattle's art gallery district. The two squares, and the district in general, are both popular with tourist and homeless people—two groups that typically peacefully coexist and can make for interesting people photography.

Other sites worth mentioning in the Pioneer Square district are the **Waterfall Garden** (33) and the **Klondike Gold Rush National Historic Park** (34). The Waterfall Garden is half a block east of Occidental Square on S Main Street (219 2nd Avenue S). The garden is a shady, peaceful oasis amid the hustle and bustle of the city. It contains a nice twenty-two-foot high man-made waterfall, trees and planters, tables and chairs. The park was built by the Annie E. Casey Foundation to commemorate the founding location of UPS (United Parcel Service).[2]

The Klondike Gold Rush National Historical Park is a block south of the Waterfall Garden at the corner of 2nd Avenue S and S Jackson Street (319 2nd Avenue S). The "park" is actually a museum dedicated to telling the history of the Klondike gold rush in Alaska, and Seattle's pivotal role in that event. It features two levels of exhibitions, including a small theater with twenty-five-minute movies about the gold rush; ranger demonstrations about mining techniques daily at 10:00 a.m. and 3:00 p.m.; and a free walking tour of the historical district starting at 2:00 p.m. each Friday, Saturday, and Sunday. The walking tours typically last between one hour and ninety minutes.

Hours

The Waterfall Garden is open daily, 8 a.m.–5:30 p.m. The Klondike Gold Rush National Historical Park opens daily at 9 a.m. in the summer (late May to early September) and 10:00 a.m. the rest of the year. It closes at 5:00 p.m. Underground tours start hourly, 10:00 a.m.–7:00 p.m., April–September, and 11:00 a.m.–6:00 p.m., October– March (shorter hours on Christmas Eve and New Year's Day; closed Thanksgiving and Christmas).

Cost

The Waterfall Garden and the Klondike Gold Rush National Historical Park are free. The Underground Tour is $19 for adults.

Contact

Pioneer Square website: www.pioneersquare.org. Underground tour website: www.undergroundtour.com. Klondike Gold Rush National Historic Park website: www.nps.gov/klse.

Location and Directions

Address: Pioneer Square itself is at the corner of Yesler Way and 1st Avenue.
Driving directions from northbound I-5: Take Exit #164A (Dearborn/James/Madison Streets), exit at James Street and turn left on James Street. James ends at Yesler; turn right. Pioneer Square will be on your right.
From southbound I-5: Take Exit #165A James Street and merge onto 6th Avenue, at James Street turn right and continue to Yesler.
Walking directions from the Smith Tower to Pioneer Square: The southeast corner of Smith Tower is on 2nd Avenue and Yesler; walk west on Yesler to 1st Avenue.
Walking directions from Pioneer Square to Occidental Square, Waterfall Garden, and Klondike Gold Rush National Historical Park: Walk one block south of Pioneer Square on 1st Avenue and turn left on Washington; Occidental Square will be on your right after half a block. Cross south across Occidental Square to Main Street and turn left; Waterfall Park will be on your left after a short block. At Waterfall Garden, turn right on 2nd Avenue and walk one block; Klondike Gold Rush National Historical Park will be on your right.

Romanesque architecture in the Pioneer Square district

Victorian pergola in Pioneer Square

Exhibit of Alaskan gold rush tableware in the Klondike Gold Rush National Historical Park

Union Station (35)

Union Station is a former train station between Pioneer Square and the International District. The outside of the building is unremarkable, but the inside is very photogenic. The station was built in 1911 and is on the US National Register of Historic Places. Train service ended at the station in 1971. It was renovated in the 1990s and in 2000 won a National Historic Preservation Award. Today, it is the headquarters for Sound Transit (the popular name for the Central Puget Sound Regional Transit Authority). The highlight of the station is its Grand Hall, complete with old-time wooden benches and white lights decorating its domed ceiling. There is not much to do here, other than see the grand hall, but it is a scenic place to walk through when visiting the Pioneer Square or International District areas.

PHOTOGRAPHY TIPS

A wide-angle lens is required to capture the entire Grand Hall, though normal to short telephoto lenses can be used for detail shots.

Door to the Women's Waiting Room in the Grand Hall of Union Station

Hours

Union Station is open Monday–Friday, 9 a.m.–5:00 p.m.

Location and Directions

Address: 401 S Jackson St. at the corner of 4th Avenue S and S Jackson Street. It should not be confused with the nearby King Street Station (which, with its clock tower, is photogenic in its own right).

Driving directions from northbound I-5: Take Exit #164A (Dearborn/James/Madison Streets), exit at James Street, and turn left on James Street. Take the second left onto 5th Avenue, then turn right onto Jackson. Union Station will be on your left.

Driving directions from southbound I-5: Take Exit #165A (James Street) and merge onto 6th Avenue; at James Street take the first left onto 5th Avenue, and turn right onto Jackson.

Walking directions from Pioneer Square (1st Avenue and Yesler): Walk south on 1st Avenue to S Jackson Street. Turn left on Jackson; go four and a half blocks and Union Station will be on your right (about two blocks past the Klondike Gold Rush National Historical Park, which is also on Jackson.)

Chinatown—International District (36–41)

Seattle is a culturally diverse city. As a major Pacific Rim port, the city has a particularly large Asian population. One of the oldest neighborhoods in the city, the Chinatown-International District is home to large populations of Chinese, Japanese, Filipino, Vietnamese, Thai, Korean, and other Asian ethnicities. The District is on the southern end of downtown, generally east and southeast of the Pioneer Square neighborhood, from approximately Yesler Way on the north to S. Dearborn Street on the south, from 4th Avenue S on the west to 12th Avenue S on the east.

The International District is an exciting place to visit to experience cultural diversity, and for photographers, it holds many colorful opportunities. By wandering through the district, you can find many **dragons** (36), which make their homes on light poles throughout the neighborhood; **a Chinese gate** (37) straddling King Street at 5th Avenue S; and, under Interstate 5, red and yellow roadway columns decorated with carp and butterflies. All are colorful and fun to photograph. For interesting food (and photography) experiences, visit one of the many dim sum restaurants or photograph the ducks hanging in grocers' front windows. Better yet, check out the open-air night market occasionally held on summer nights—see the Chinatown-International District Business Improvement Area (CIDBIA) website for dates and times.

Along the northern boundary of the district is **Kobe Terrace Park** (38) (north of S Main Street between 6th and 7th Avenues). This small park has views of south Seattle, as it sits on a hillside overlooking the district. It is adorned with cherry trees

Lamppost dragon in the International District

200-year old Yukimidoro stone lantern in Kobe Terrace Park

and in its upper part is a four-ton stone lantern donated by the city of Kobe. The park is especially beautiful in the spring when the cherry trees are blooming. On the hillside adjoining the park is the Danny Woo Community Garden. Paths through the garden venture by terraced plots, dozens of fruit trees, and a large chicken coop.

In the heart of the District, at Maynard Avenue and King Street, **Hing Hay Park** (39) is a gathering place for cultural events. It also houses the colorful Grand Pavilion. For a special visit, come to the park during Chinese New Year (the date changes each year, but is usually in late January or early February) when Chinese lions and dragons roam the streets, or during the Dragon Fest (annually in July).

Several blocks east of Hing Hay Park along King Street is the **Wing Luke Museum of the Asian Pacific American Experience** (40), also known as The Wing. Both a National Park Service and Smithsonian affiliate, this museum is the only one in the United States dedicated to the Asian Pacific American experience. The museum is unique in that admission combines a guided tour with entrance to the museum's galleries. Several tours are available (at different price points) including a tour of the Historic East Kong Yick building, a hotel that thousands of Asian immigrant workers first called home in America; a tour of the neighborhood through the eyes of a local; the Bruce Lee tour, which guides visitors through the famous martial artist's Seattle stomping grounds and includes a meal of his favorite dishes at a local restaurant; and seasonal food-related tours. The galleries are dedicated to both the historic and the present-day Asian American experience.

For a totally different experience, consider visiting the **Seattle Pinball Museum** (41), which also makes its home in the International District, half a block south of Hing Hay Park on Maynard Avenue. Perhaps more of an arcade than a museum, the price of admission includes unlimited play at more than fifty pinball machines dating back to the 1930s.

The Gee How Oak Tin Family Association room, part of a free tour offered by the Wing Luke Museum of the Asian American Experience, *photo by Linsday Kennedy Photography*

Hours

The Wing Luke Museum is open Tuesday–Sunday, 10:00 a.m.–5:00 p.m. The Seattle Pinball Museum is open Wednesday through Monday. Closes at 5:00 p.m., except Thursday–Saturday when hours extend to 10:00 p.m.

Cost

Ticket prices for the Wing Luke Museum vary depending on the tour selected, but start at $14.95. Admission to the Seattle Pinball Museum is $13 for adults.

Contact

CIDBIA website: www.cidbia.org; phone: 206.382.1197; email: info@cidbia.org. Wing Luke Museum of the Asian Pacific American Experience website: www.wingluke.org; phone: 206.623.5124; email: tours@wingluke.org. Seattle Pinball Museum website: www.seattlepinballmuseum.com; phone: 206.623.0759; email: info@seattlepinballmuseum.com

Directions

Addresses:
Kobe Terrace Park: 650 S Main Street.
Hing Hay Park: 423 Maynard Avenue S.
Wing Luke Museum of the Asian Pacific American Experience: 719 S King Street.
Seattle Pinball Museum: 508 Maynard Avenue S.

Plaza in Hing Hay Park, International District

Driving directions from northbound I-5: Take Exit #164A (Dearborn/James/Madison Streets), take the first exit to Dearborn Street and turn left on Dearborn. You'll be at the southern end of the district; turn right on 6th Avenue S to enter the heart of the district.
From southbound I-5: Take Exit #165A (James Street) and merge onto 6th Avenue; continue on 6th Avenue past Yesler Way to enter the district.

Walking directions from Union Station: The International District is across 5th Avenue from Union Station. To reach the Chinese gate at S King Street, walk south on 5th from Jackson one block, and turn left onto King Street. Hing Hay Park is two blocks ahead on the left. From there, Kobe Terrace Park is left two blocks on Maynard Avenue, the Seattle Pinball Museum is right half a block on Manyard, and The Wing is ahead two blocks on King Street.

Rizal Viewpoint (42)

Dr. Jose Rizal Park and the adjacent Rizal Bridge offer one of the iconic views of downtown Seattle, sans Space Needle. The view extends from the Port of Seattle through the southern side of downtown, incorporating Elliott Bay, Safeco and Century Link fields, the Smith and Columbia Towers, and other downtown skyscrapers. In front of downtown is the "spaghetti" intersection of Interstate 5 and Interstate 90. For those with canine friends, the park contains an off-leash area (reportedly there is also a hole in the fence of the dog park with a particularly good view). The park contains restrooms, picnic tables, and a small play area for children.

PHOTOGRAPHY TIPS

Though it does make a good morning shot, with light coming from the east or southeast, I think the view is particularly good at or after sunset when headlights and taillights on the freeways create visual red and white trails (with long exposures). In the park, you can frame downtown with trees in the foreground. However, I prefer the view from the Rizal Bridge on 12th Avenue. If shooting on the bridge, beware that city buses and other traffic can cause vibrations, blurring long exposures even when using a tripod. Try to time your exposures when there is no traffic on the bridge.

Hours

The park is open daily, 4:00 a.m.–11:30 p.m.

Directions

Address: The park is at 1008 12th Avenue S. The Rizal Bridge is on 12th Avenue to the north of the park.

Driving directions from northbound I-5: Take Exit #164 (Dearborn/James/Madison Streets), then take the Dearborn Street ramp. Turn left on Dearborn, pass under the freeway, then turn right on 8th Avenue S; in three blocks, turn right on S. King Street and continue to 12th Avenue South. Turn right and cross the Rizal Bridge; turn right immediately after the bridge to stay on 12th Avenue S and reach the park.

From southbound I-5: Take Exit #164 for Interstate 90 E toward Bellevue/Spokane, keep right and follow signs to Dearborn Street. Turn right on Dearborn, right again on 8th Avenue S, and then follow the directions above for northbound Interstate 5.

Walking directions from Hing Hay Park in the International District: Walk east on S King Street to 12th Avenue S.; turn right on 12th Avenue S and walk across the bridge; turn right just past the bridge to enter the park. The distance from Hing Hay Park to Dr. Jose Rizal Park is approximately 0.8 miles.

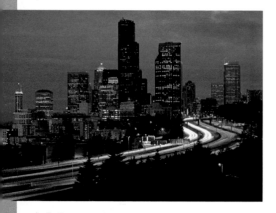
Twilight view of downtown Seattle from the Rizal Bridge

NORTH OF DOWNTOWN AND SOUTH LAKE UNION

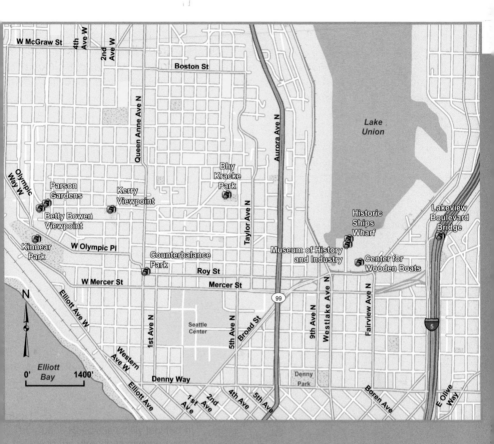

The area north of downtown is dominated by Queen Anne Hill and Lake Union. Queen Anne is mostly residential, but does offer perhaps the best viewpoint in Seattle. The southern shore of Lake Union is filled with numerous restaurants, the 12-acre Lake Union Park, and other public spaces.

South Lake Union has a maritime feel as it houses the Center for Wooden Boats and the Historic Ships Wharf, in addition to having several marinas and two sea-plane bases (Kenmore Air, www.kenmoreair.com, and Seattle Seaplanes, www.seattleseaplanes. com, both offering scenic flights above Seattle). The houseboats of Seattle, made famous by the movie *Sleepless in Seattle*, also mostly reside on Lake Union, though not on the south shore. If you want to see or photograph the houseboats, you may wish to book one of the many boat tours that leave from the South Lake Union area, though some can also be photographed from Gasworks Park (see page 106) on the northern shore of the lake.

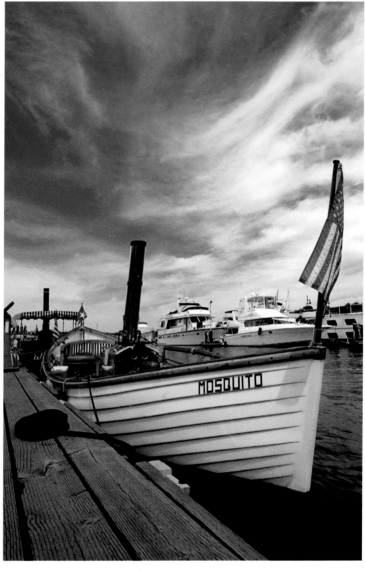

Small steam-powered wooden boat at the Center for Wooden Boats

Kerry Park (43)

Kerry Park, which overlooks downtown Seattle from the southern end of Queen Anne Hill, boasts perhaps the best view in the city. The view from this small but very popular park covers the Space Needle, the downtown area, the waterfront, Elliott Bay, and (at least on clear days) Mount Rainier. The park is so popular with photographers at sunset that it can sometimes be hard to find a place to set up a tripod. It is also spectacular at night, particularly on fall and winter weekdays when the office buildings in the city are still active after sunset.

PHOTOGRAPHY TIPS

Depending on the time of year, sunrise shots can be good here. However, late afternoon through sunset are the peak photographic times for the park. If you come for the sunset, it's definitely worth sticking around as the daylight fades for a city lights shot as well.

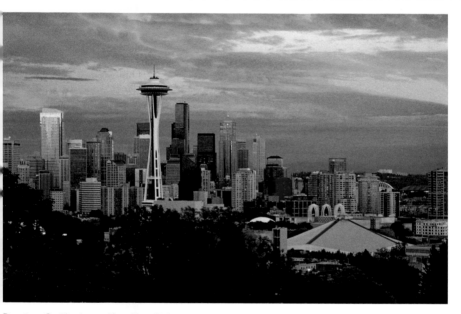

Downtown Seattle at sunset from Kerry Park

Location and directions

Address: 211 W Highland Drive. **Driving directions from I-5:** Take the Mercer Street Exit (#167). At the bottom of the (long) off-ramp, continue straight onto Mercer Street for about one mile, then turn right on Queen Anne Avenue N. Go up the hill five blocks and turn left onto W Highland Drive. Kerry Park is two blocks on the left.

Hours

This is one of the few Seattle parks open twenty-four hours a day.

Betty Bowen Viewpoint and Parson Gardens (44 & 45)

While at Kerry Park, it's worth walking down the street to Marshall Park, home to the **Betty Bowen Viewpoint** (44), for a more southwesterly to westerly view. With an expansive view of Elliott Bay, Puget Sound, and the Olympic Mountains, this can be a better spot to view and photograph sunsets than Kerry Park, though it is missing the view of downtown.

Across the street from Marshall Park is another small park, **Parson Gardens** (45). This tranquil little garden can be very photogenic if you catch it while the flowers are blooming. Perhaps the best time to visit is the spring, when the rhododendrons are in bloom. It's worth popping in for a look if you're visiting Marshall Park.

PHOTOGRAPHY TIPS

It is easily possible to photograph the setting sun on the city and Space Needle at Kerry Park, then to walk down to Marshall Park for some shots of the Sound and Olympics for late- and post-sunset colors, then back to Kerry Park for more city shots after the city lights come on.

Hours

Parson Gardens is open daily, 6:00 a.m.–10 p.m. Marshall Park is open daily, 4:00 a.m.–11:30 p.m.

Location and Directions

Marshall Park is at the southwest corner of 7th Avenue W and W Highland Drive. Parson Gardens is on the northeast corner of the same intersection. Both are five blocks west of Kerry Park on Highland Drive. Driving directions to Kerry Park are on page 69.

Elliott Bay and Alki Point from the Betty Bowen Viewpoint

Center For Wooden Boats (46)

The **Center for Wooden Boats** is a hands-on museum on the east side of Lake Union Park dedicated to maritime history and small wooden boat heritage. The center maintains a fleet of historic boats, many of which are available for rent, including sail boats, rowboats, canoes, and paddleboats. The center also offers free boat rides every Sunday. There are always interesting things to see and photograph on their docks. In addition to the over-water section of the center, be sure to spend some time on the land portion, where you can watch boats under repair or take a class on woodworking. There is plenty to do at the center: sailing classes, kayak building, toy boat building and sailing, and more. Classes and activities are available for adults, youth, children, and families. Every summer, the center is home to the Annual Lake Union Wooden Boat Festival, which displays over 100 wooden boats, from dinghies to 130-foot schooners.

PHOTOGRAPHY TIPS

You can use a variety of lenses here. Because space is limited on the docks, wide-angle lenses come in handy when trying to capture an entire boat in your composition. A mid-range zoom works well for isolating details of the boats or their reflections in the lake. Morning is a good time to visit, as the lake is usually calmer, providing better reflections than in the afternoon. At the on-shore portion of the center, look for chains, ropes, and various boat parts that can make interesting close-up shots.

Boat docked on Lake Union at the Center for Wooden Boats

Cost

The Center for Wooden Boats and the Annual Lake Union Wooden Boat Festival both have free admission. Prices to rent boats and attend classes vary. Many of the classes require advance registration.

Hours

The center is open daily in the summer and early fall, and is closed on Tuesdays the rest of the year. The center always opens at 10:00 a.m. but has various closing times throughout the year ranging from 5:00 p.m. to 8:00 p.m. Boat rentals are available daily in the summer, but only on weekends in the winter. Rental hours also vary; contact the center for details.

Contact

The center's website: www.cwb.org; email: info@cwb.org; phone: 206.382.2628.

Location and directions

Address: 1010 Valley Street.
Driving directions from I-5: Take the Mercer Street Exit (#167) and continue straight onto Mercer. Turn right on Terry Avenue N. Continue straight into the Lake Union Park parking lot. The center is at the east end of Lake Union Park. A few spots in the parking lot are reserved for center visitors.

Historic Ships Wharf (47)

The **Historic Ships Wharf** is operated by the Northwest Seaport Maritime Heritage Center. The center maintains three historic vessels at the wharf as well as other "partner" vessels (not owned by the center). Two of the center's ships, the tugboat *Arthur Foss* and the Lightship No. 83 *Swiftsure*, are National Historic Landmarks. The *Arthur Foss* was built in 1889 and has a long history of working from Alaska to Hawaii, including starring in the 1934 movie *Tugboat Annie*. She was decommissioned in 1970. Self-guided tours are available on the *Arthur Foss* on weekends and during special events. Additionally, during the summer, visitors can have a "tugboat sleepover," by spending the night in the *Arthur Foss*'s crew or officer quarters.

Swiftsure was built in 1904 and is one of the oldest lightships in the country. She has served on both the East and West Coasts, retiring in 1961. *Swiftsure* is currently undergoing restoration by the center. She is also normally open to the public on weekdays as well as weekends. Northwest Seaport's third vessel is the 1933 fishing boat *Twilight*. She was built at Fishermen's Terminal in Seattle and was an active hook-and-line troller boat into the 1980s.

1933 fishing troller *Twilight* at the Historic Ships Wharf

The center also sponsors free Chantey Sings, at various locations, but often on the ships at the wharf, the second Friday of each month. Or if you prefer to work rather than sing, Northwest Seaport regularly schedules volunteer work parties on their three ships.

Partner vessels at the wharf include the 1922 steamship *Virginia V* and the 1910 fireboat *Duwamish*. The *Virginia V*, the last remaining steamer of Seattle's famous Mosquito Fleet, is occasionally open to visitors. The *Duwamish* prowled the Seattle waterfront until 1985; she was the most powerful fireboat in the world, being able to deliver a fire flow of 22,800 gpm, until 2003 (when a new fireboat for the city of Los Angeles claimed the record). The wharf is also home to the schooner *Lavengro*, the last original Biloxi "White Winged Queen" schooner in the world. Free rides are available on the *Lavengro* most Sundays (arranged through the Center for Wooden Boats).

Hours

Lake Union Park is open 4:00 a.m.–11:30 p.m., and as part of the park, the Historic Ships Wharf has the same hours. The ships on the wharf do not keep regular hours, though the *Arthur Foss* is normally open for tours on weekends, noon–4:00 p.m. Through the Center for Wooden Boats, the *Lavengro* hosts free sailings most Sundays and can also be chartered. The *Virginia V* is occasionally open for public events or can be chartered.

Cost

There is no cost to walk on the Historic Ships Wharf. Self-guided tours of the *Arthur Foss* and *Swiftsure*, the Chantey Sings, and Sunday sailings on the *Lavengro* are also free. Overnight stays on the *Arthur Foss* are $49 for a crew berth, $79 for an officer's cabin, or $495 for the entire ship (which sleeps nine).

Contact

Northwest Seaport Maritime Heritage Center website: www.nwseaport.org; email: info@nwseaport.org; phone: 206. 447.9800. *Virginia V* website: www. virginiav.org; email: info@virginiav.org; phone: 206.624.9119. *Lavengro* website: www.schoonerlavengro.com; email: info@ schoonerlavengro.com; phone: 206.577.7233.

Location and directions

The Historic Ships Wharf is in Lake Union Park, north of the Museum of History and Industry. The park's address is 860 Terry Avenue N. Follow the directions on page 71 for the Center for Wooden Boats.

1922 steamship *Virginia V*, part of Seattle's original mosquito fleet

PHOTOGRAPHY TIPS

The ships are docked bow-first into the wharf, but the side floats between the ships may or may not be open. Therefore many of your shots will be from the front of the boats. Similar to the Center for Wooden Boats, the narrowness of the space on the wharf makes wide-angle lenses helpful here. Telephoto lenses are useful for shooting boat details.

Museum of History & Industry (48)

Immediately adjacent to the Historic Ships Wharf and west of the Center for Wooden Boats is the **Museum of History & Industry (MOHAI)**, housed in its new home (which opened in December 2012)—the former Naval Reserve Building (the Armory). MOHAI is dedicated to sharing the history of Seattle and the Puget Sound region and, according to its website, has nearly four million artifacts, archives, and photographs in its collection. The museum has several permanent exhibits, as well as temporary exhibits that change on a regular basis, so it's worth checking out their website to see if the current exhibits are of interest. Past temporary exhibits included a 1930s Seattle built out of Legos, a look at the WTO protests in Seattle, the Hall of Icons and Eye Candy, and a look at the arts and craft movement in the Pacific Northwest. The permanent exhibits include *Maritime Seattle*, which examines the city's relationship with water; *True Northwest: the Seattle Journey*, where visitors explore twenty-five different "snapshots" of historic Seattle; and the *Bezos Center for Innovation*, which, through interactive exhibits, examines how innovation shaped the Puget Sound area and changed the world. The exterior of the building, featuring art deco designs, is photographic itself. The building is on the National Register of Historic Places.

Hours

The MOHAI is open daily, 10:00 a.m.–5:00 p.m., and until 8:00 p.m. on Thursdays. Holiday hours may vary. Closed Thanksgiving Day and Christmas.

Cost

Adult admission to MOHAI is $17; first Thursdays of each month are free.

Contact

MOHAI website: www.seattlehistory.org; phone: 206.324.1126; email: information@mohai.org. The director of marketing and communication, Jackie Durbin, can be reached at Jackie.durbin@mohai.org or at the main phone number, extension 120.

Location and directions

The Museum of History and Industry is in Lake Union Park (860 Terry Avenue N). Follow the directions on page 71 for the Center for Wooden Boats. Parking is available at the AGC lot at 1200 Westlake Avenue N, which is a third of a mile west of the museum. Parking tickets from the AGC lot can be validated at the museum's front desk.

PHOTOGRAPHY TIPS

By shooting from the Historic Ships Wharf, you may be able to get a ship in the foreground and the MOHAI building in the background.

PHOTOGRAPHY RESTRICTIONS

Flash photography is prohibited inside the museum. To use your photographs commercially, contact the museum's director of marketing and communication.

Museum of History and Industry from Lake Union Park

UNIVERSITY OF WASHINGTON

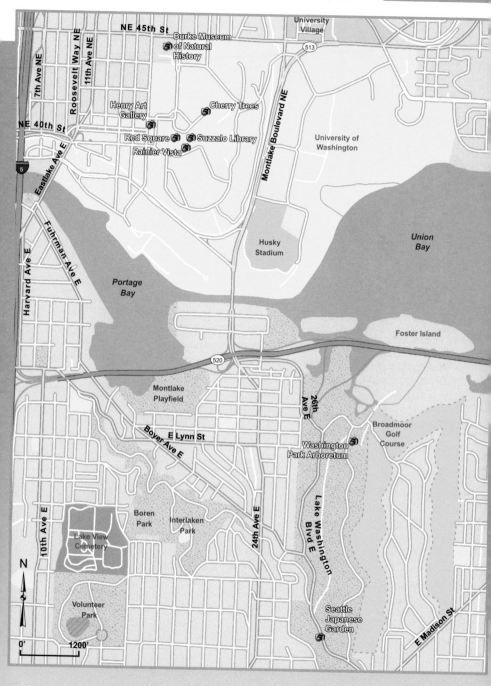

Originally founded in 1861 in an area now encompassed by downtown Seattle, the University of Washington moved to its current campus along the shores of Lake Union and Lake Washington in 1885. The campus was the site of the 1909 Alaska-Yukon Pacific Exposition. Though few buildings survive from the world's fair, its layout continues to shape the campus today. Perhaps the fair's main legacies are the photogenic Rainier Vista and Drumheller Fountain. Many of the most photogenic buildings on campus today were built in the early twentieth century, including those forming "The Quad" (completed in the early 1930s)[1] and Suzzallo Library (opened in 1926).[2] In addition to the main campus, the university operates the Washington Park Arboretum. The university is fondly known by many Washingtonians as UW or U-Dub.

■ ■ ■ ■ ■ ■ ■ ■ ■ ■ ■ ■ ■ ■ ■ ■ ■

Main Campus (49–52)

The main UW campus is large, covering more than 700 acres. There are many photographic attractions on the campus, including architecture, gardens, Mount Rainier views, and people, of course, as the university has more than 40,000 students. An entire day could be spent photographing on campus without covering it all.

Of course, the campus can be visited any time of year, but perhaps the best time is in the spring when the **cherry trees** (49) are blooming. There are several spots on the campus with cherry trees, but the most iconic spot is The Quad, officially known as the Liberal Arts Quadrangle. The inside of The Quad, which is formed by seven buildings, is ringed by majestic cherry trees that erupt with blossoms in late March and early April.

PHOTOGRAPHY TIPS

Wide-angle to telephoto lenses are useful for capturing everything from sweeping views of the cherry trees to closeups of individual flowers. The classic brick buildings make good backgrounds for the trees. When school is in session, the campus can be crowded, especially during class breaks. This can present a problem if you are trying to have few or no people in your shots. However, after being on campus a while, you will note the ebb and flow of foot traffic, and can still capture shots with few people in the frame by timing your shots and taking advantage of the periods when class is in session. Other options are to visit early or late in the day when fewer classes are in session or on a weekend.

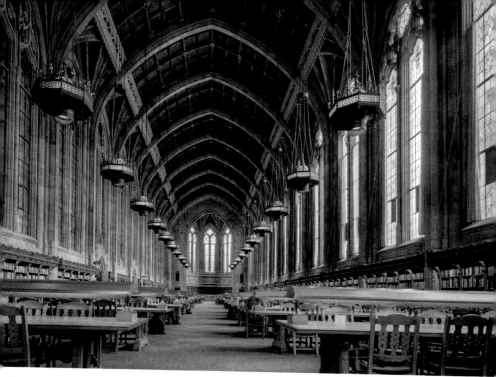

Graduate Reading Room, Suzzallo Library, University of Washington

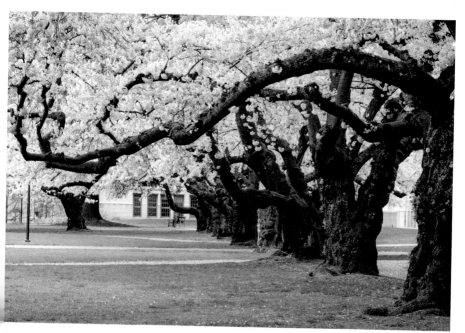

Spring, when the cherry trees in the Quad bloom, is a great time to visit the University of Washington.

Nearby and southwest of The Quad is **Red Square** (50)—a large brick-paved plaza officially known as Central Plaza (though when I was a student there, I never heard it called that). Red Square forms the central hub of the campus. Five buildings surround Red Square; the most photogenic of which is **Suzzallo Library** (51), built in the collegiate Gothic style complete with terra-cotta sculptures and stone coats of arms. When visiting Suzzallo, be sure to go inside and up the Grand Staircase to the Graduate Reading Room. The reading room spans the entire third floor and has an impressive vaulted ceiling. The western wall of the reading room, facing Red Square, features colorful, tall stained-glass windows.

PHOTOGRAPHY TIPS

Photographing in the Graduate Reading Room can be difficult because of the extreme contrasting light conditions—HDR techniques work well here. The reading room is also extremely quiet, so if your camera has the capability to turn off its focus-lock and shutter sounds, be kind to the students and do so. The Grand Staircase is another popular subject inside the library.

The most impressive view on campus is at the southeastern exit out of Red Square (next to Suzzallo)—lining up Drumheller Fountain down the alley of **Rainier Vista** (52) to Mount Rainier itself. Wander down to the fountain to visit the rose gardens surrounding it.

PHOTOGRAPHY TIPS

To photograph the Rainier Vista, shoot from the stairs leading out of Red Square, or back up and include the corner of Suzzallo and Gerberding Hall in your composition. The light will usually be best in the late afternoon through sunset. With luck, Drumheller Fountain will be active (though in my experience, it often is not).

PHOTOGRAPHY RESTRICTIONS

Large commercial shoots are allowed by permit only; see www.washington.edu/mediarel/filming-on-campus for more information. According to Harry Hayward, the director of digital analytics for the university, small, independent shooters do not necessarily need a permit, but he suggests they contact the university for permission. The university's main concerns are about disrupting university functions, using staff time, and protecting use of its iconic scenes (such as the Rainier Vista and Suzzallo Reading Room) from commercial exploitation without permission.

Grand Staircase, Suzzallo Library

Contact

Website: www.washington.edu; visitor center email: uwvic@uw.edu; phone: 206.543.9198. Contact for commercial photography: Alanya Cannon, director of brand management, alcan@uw.edu, 206.616.5535.

Location and Directions:

Address: There are many entrances to the campus. The closest to Red Square, The Quad, and the Henry Art Gallery (see page 81) is Gate 1 at 15th Avenue NE and NE 41st Street, which leads to a large parking garage under Red Square. Another option is to enter at the North Gate (Gate 2) off NE 45th Street. Parking before 5:00 p.m. on weekdays is $15 per day, with refunds available for less than four hours. Parking on weekdays, 5:00 p.m.–9:00 p.m., and Saturdays, 7:00 a.m.–noon, is $5. Rates may be higher during special events (such as Saturday football games in the fall).

Driving directions from I-5: Take Exit #169 for NE 45th Street and turn east on 45th. Turn right on 15th Avenue NE after approximately 0.25 miles. Continue south on 15th Avenue three blocks to NE 41st Street, and turn left into Gate 1. Stop at the gatehouse for a parking permit for Red Square parking. Alternatively, continue on 45th Street to 17th Avenue NE, and turn right onto campus at Gate 2.

The University of Washington also has two fine museums. The first is the **Burke Museum of Natural History and Culture**. Founded in 1885, the Burke Museum is the oldest public museum in the State of Washington. It is also the official state museum of Washington.[3] The museum's collection has more than sixteen million objects covering geology, archaeology, and paleontology, as well as plants, fish, shells, mammals, reptiles, and amphibians. Its collection of Native American art and artifacts is the fifth largest in the United States.[4] The museum hosts several temporary exhibits every year and currently displays three long-term exhibits: *Pacific Voices*, about native cultures around the Pacific; *Life and Times of Washington State*, which examines the natural forces and animals of the region over the past 500 million years; and the Erna Gunther Ethnobotanical Garden, with more than 100 species of Pacific Northwest plants and featuring those important to Native Americans.

The museum is currently undergoing a major renovation and expansion, with the new museum building expected to open in 2018. According to the Burke Museum website, the "New Burke" will "break down barriers between public and 'back-of-house' spaces, integrating collections and research labs with traditional galleries to create an experience that invites everyone—from curators to visitors, educators to students—to engage in the dynamic process of scientific and cultural discovery."

PHOTOGRAPHY RESTRICTIONS

Personal, non-commercial photography is allowed, except as posted. "Excessive" use of flash, tripods, and monopods is prohibited. Photography may be restricted in some special exhibits. Written permission is required for commercial photography and sale or publication of photographs.

Hours
The Burke Museum is open daily, 10:00 a.m.–5:00 p.m.

Cost
Adult general admission is $10. Free admission is available on the first Thursday of each month.

Contact
Website: www.burkemuseum.org; phone: 206.543.5590; email: theburke@uw.edu.

Location
The Burke Museum is near the corner of 17th Avenue NE and NE 45th Street. The nearest parking is via Gate 2 on 17th Avenue south of 45th Street (see the driving directions for the campus on page 79).

Totem pole at the Burke Museum of Natural History and Culture, *courtesy of Fallen Log Photography*

Henry Art Gallery (54)

Also on the main campus is the **Henry Art Gallery**, which is largely dedicated to contemporary art and the history of photography. Founded in 1926 as the first art museum in Washington State, the Henry's collection now has over 25,000 objects and is particularly strong in photography. The collection also includes sculpture, costumes, textiles, ceramics, videos, paintings, and other works on paper. Visitors can request to see specific works in the collection (up to twenty per visit) in the museum's Eleanor Henry Reed Collection Study Center.

Hours

The Henry opens at 11:00 a.m. on Wednesday through Sunday and closes at 4:00 p.m. on Wednesday, Saturday, and Sunday and at 9:00 p.m. on Thursday and Friday. Appointments for the Eleanor Henry Reed Collection Study Center are available Tuesday–Friday, 9 a.m.–5:00 p.m., with limited appointments on Thursdays and Fridays, 5:00 p.m.–9:00 p.m.

Cost

Adult general admission is $10. Free admission is available on the first Thursday of each month.

Contact

Website: www.henryart.org; phone: 206.543.2280; email: info@henryart.org. For special photography requests, email: operations@henryart.org. Eleanor Henry Reed Collection Study Center phone: 206.616.9630; email: contact-collections@henryart.org.

Portion of the exterior of the Henry Art Gallery

Location and directions

Address: The Henry Art Gallery is near the corner of 15th Avenue NE and NE 41st Street. The closest parking is under Red Square via parking Gate 1 (see the driving directions for the campus on page 79).

PHOTOGRAPHY RESTRICTIONS

Personal, non-commercial photography is allowed unless posted otherwise. Flash photography is prohibited. Video cameras and tripods are allowed with advanced permission.

Washington Park Arboretum and
Seattle Japanese Garden (55 & 56)

South of the main campus, across the Montlake Cut and on the shores of Lake Washington, is the **Washington Park Arboretum** (55). This green oasis within the city is a haven for nature and flower lovers and photographers. The arboretum contains 230 acres of woods and wetlands, and its collections include more than 10,000 plants from around the world. The northern portion of the arboretum includes natural, undeveloped areas on the mainland and on Foster and Marsh Islands. This area can be accessed by foot trails (see walking directions on page 83) or by canoe and kayak on Lake Washington. Near the southern end of the arboretum is the **Seattle Japanese Garden** (56), for those who like their nature more controlled and sculpted.

In between the undeveloped north and the Japanese Garden are the main arboretum grounds. This portion of the arboretum has specific areas dedicated to magnolias, camellias, Asiatic maples, Japanese maples, oaks, rhododendrons, and other trees and shrubs. There is also a Winter Garden, a Woodland Garden, and a Pacific Connections Garden (with plants from around the Pacific Rim). Multiple trails connect the many garden areas. The main path through the arboretum, leading from the visitor center to the Seattle Japanese Garden, is Azalea Way, which is loaded with colorful azaleas and rhododendrons in the spring. While spring (typically peaking in May) and autumn (usually peaking in October) provide the most colorful photographic opportunities, there is something to see in any season. The visitor center maintains a list of what's blooming and can provide directions to any flowering action.

PHOTOGRAPHY RESTRICTIONS

Commercial photography is restricted in the Seattle Japanese Garden except for photographers purchasing an annual photographer membership for $75. Further, tripods are not allowed in the Seattle Japanese Garden except for photographer members, and then only on special photographer-only hours, which occur from 8 a.m. to 10:00 a.m. twice a month from April through October and once in November.

In the spring, colorful azaleas and rhododendrons line Azalea Way through the Arboretum.

Hours

The arboretum is open daily, dawn to dusk. The Graham Visitors Center is open daily, 10:00 a.m.–5:00 p.m. The Seattle Japanese Garden, which is operated by Seattle Parks and Recreation rather than the University of Washington, opens at 10:00 a.m. and has variable closing hours depending on the season, generally ranging from 4:00 p.m. in mid-fall through mid-spring to 7:00 p.m. in summer.

Cost

The Washington Park Arboretum is free. Adult admission to the Seattle Japanese Gardens is $6.

Contact

Washington Park Arboretum website: www.uwbotanicgardens.org; email: uwbg@u.washington.edu. Seattle Japanese Garden: website: www. seattlejapanesegarden.org; phone: 206.684.4725.

Location and directions

Washington Park Arboretum address: The Graham Visitor Center is at 2300 Arboretum Drive E.

Driving directions from I-5: Take Exit #168 (SR-520 East/Bellevue-Kirkland). Once on SR 520, take the first exit for Montlake Boulevard. Continue straight through the stoplight and take a slight right then a slight left at Lake Washington Boulevard. At the stop sign, turn left onto E Foster Island Road then right onto Arboretum Drive E. From the main campus, drive south on Montlake Boulevard across the Montlake Bridge, turn left onto E Lake Washington Boulevard, and follow the directions above.

Washington Park Arboretum, walking directions: From the southeast portion of the main campus (from the corner of NE Pacific Street and Montlake Boulevard) to the Graham Visitor Center covers approximately 1.5 miles. However, most of the walk is on trails rather than streets. To make this walk, cross the Montlake Bridge and turn left onto the Arboretum Waterfront Trail/Foster Island Trail just past the end of the bridge. At the end of the Montlake Cut, the trail turns south and then east, crossing a bridge onto Marsh Island. It crosses another bridge on the east end of the island onto Foster Island. On Foster Island, the trail comes to a "T" intersection. Turn right and stay on the trail until it comes out at the intersection of E Foster Island Road and Arboretum Drive E. Continue straight onto Arboretum Drive.

Seattle Japanese Garden address: 1075 Lake Washington Boulevard E.

Driving directions from I-5: Follow the directions for the arboretum, except keep straight on Lake Washington Boulevard (rather than turning on Foster Island Road). Less than a mile past the turn to Foster Island Road, the Japanese garden will be on the left.

Seattle Japanese Garden, walking directions: The Japanese garden is near the southwestern corner of the arboretum. From the Graham Visitors Center, cross Arboretum Drive E and walk the full length of the Azalea Way trail. At the end of the trail, cross Lake Washington Boulevard and continue south along the road to the entrance of the Japanese garden. It may be helpful to get a trail map and directions from the visitor center.

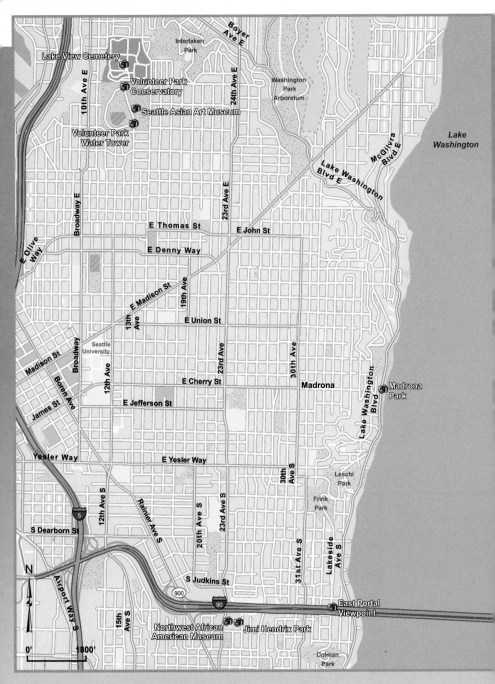

Lake View Cemetery

Volunteer Park
Conservatory

Seattle Asian Art Museum

Volunteer Park
Water Tower

10th Ave E

24th Ave E

Boyer Ave E

Interlaken Park

Washington Park Arboretum

Lake Washington

McGilvra Blvd E

Lake Washington Blvd E

Broadway E

23rd Ave E

E Thomas St

E John St

E Denny Way

E Olive Way

13th Ave

E Madison St

19th Ave

E Union St

Madison St

Boren Ave

Broadway

12th Ave

Seattle University

23rd Ave

E Cherry St

30th Ave

Madrona

Madrona Park

James St

E Jefferson St

Yesler Way

E Yesler Way

Leschi Park

Lake Washington Blvd

Frink Park

S Dearborn St

12th Ave S

Rainier Ave S

20th Ave S

23rd Ave S

30th Ave S

31st Ave S

Lakeside Ave S

I-5

N

Airport Way S

15th Ave S

S Judkins St

900

90

East Portal Viewpoint

Northwest African American Museum

Jimi Hendrix Park

Colman Park

0' 1800'

Most of Seattle is on a strip of land bounded on the west by Puget Sound and on the east by Lake Washington. The area east of downtown rises up as Capital, First, and Beacon Hills, and eventually slopes down to the western shore of Lake Washington. South of the University of Washington, most of the area is residential. However, there are several interesting parks in the area. Volunteer Park sits on top of Capital Hill and not only offers views of the city (check out the view from the top of the water tower) but also has a splendid conservatory. The Seattle Asian Art Museum is also in the park. Much of the shore of Lake Washington is public parklands, with views across the lake to Mercer Island and southeast to Mount Rainier. While most of the shoreline parks are but a thin strip of land, the lakeshore's crown jewel, Seward Park (described in the South Seattle section, page 113), is a broad peninsula surrounded by lake waters.

Volunteer Park (57–59)

The **Volunteer Park Conservatory** (57) is a Victorian-style greenhouse modeled after London's Crystal Palace[1] and contains more than 3,426 glass panes.[2] The conservatory, which was built in 1912, contains five "houses"—the bromeliad house, the palm house, the fern house, the cactus house, and the seasonal-display house. Thirty- to sixty-minute docent-guided tours are available free of charge by advanced reservation (minimum two-week notice required).

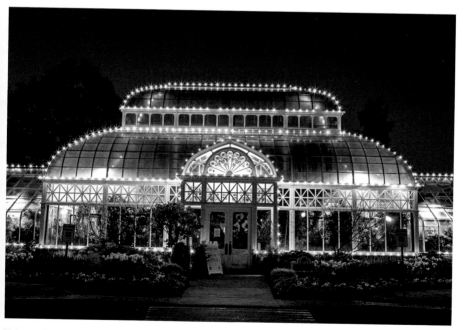

Volunteer Park Conservatory

PHOTOGRAPHY TIPS

The light in the conservatory, especially on cloudy or rainy days when contrast is minimal, is wonderful for closeups and macro photography. When shooting closeups, a tripod is very useful. However, space along the walkways in the conservatory is extremely limited, so tripods are only allowed on weekdays and must be moved for other guests. If you are visiting when it is cold and damp outside, condensation on camera lenses can be a problem—three of the houses have tropical (warm and humid) climates. Allow your equipment time to adjust to conditions before shooting. The outside of the conservatory with its thousands of glass panels is also photogenic, especially in the winter when it is decorated with lights for the holiday season.

The park can be fun to visit at or after sunset. You can shoot the sunset skies with Black Sun and the Space Needle or the city view from the top of the water tower. Then, as darkness falls, shoot the Asian Art Museum, whose beautiful front windows are lit from inside, and the conservatory, which is decorated with white lights.

PHOTOGRAPHY RESTRICTIONS

Tripods are allowed in the conservatory weekdays only (or after-hours by arrangement) and must be moved, if necessary, to accommodate other visitors. Commercial and editorial photography requires a $25 permit from Seattle City Parks. Depending on your plans, you may need to schedule commercial photography for after-hours (for an additional fee).

In the Seattle Asian Art Museum, photography is allowed for personal, non-commercial purposes except in a few select galleries and selected art pieces marked with a "no photography" symbol. Tripods, "selfie sticks," flash photography, and video cameras are prohibited.

The sculpture Black Sun is copyrighted by the Isamu Noguchi Foundation and Garden Museum, and photographs of it for non-personal use are prohibited by copyright laws without express written permission, which may be obtained from the Artists Rights Society (ARS) New York.

While at the conservatory, it is worth walking south to the **Seattle Asian Art Museum** (58), which is part of the Seattle Art Museum system. The view from the museum is westward toward the Olympic Mountains. In front of the museum is a black doughnut-shaped sculpture called *Black Sun*. A fun shot is to line up the Space Needle in the center of the sculpture's hole. The small museum is dedicated to Chinese, Indian, Japanese, Korean, and Southeast Asian art, and if you enjoy this type of artwork, it may be worth a visit—however, the exhibits can be difficult to photograph because of poor light. Occasionally free tours are available. Photographically, the building itself is worth shooting. Built in 1933 in the art moderne style, it features an impressive front entrance flanked by two camel statues.

A bit farther south from the Asian Art Museum is the **Volunteer Park water tower** (59). Climb the 100 steps up the tower to a 360-degree view of the city. It is the highest free viewpoint in the city.

Hours

Volunteer Park is open daily, 6:00 a.m.–10:00 p.m. The conservatory is open Tuesday–Sunday , 10:00 a.m.–4:00 p.m. The Seattle Asian Art Museum is open Wednesday–Sunday, 10:00 a.m.–5:00 p.m., except for Thursday when it closes at 9:00 p.m.

Cost

Admission to the conservatory is $4 for adults, with free admission on the first Thursday and first Saturday of each month. Adult admission to the Seattle Asian Art Museum is $9. The museum also has free admission the first Thursday of each month.

Contact

Seattle City Park website: www.seattle. gov/parks/parkspaces/VolunteerPark/ conservatory.htm. Friends of the Conservatory website: www. volunteerparkconservatory.org; phone: 206.684.4743. Seattle Asian Art Museum website: www.seattleartmuseum.org/visit/ asian-art-museum; phone: 206.654.3100.

Flowers in the seasonal-display house of the Volunteer Park Conservatory

Location and directions

Addresses: The conservatory is at 1400 E Galer Street. The Seattle Asian Art Museum is at 1400 East Prospect Street. **Driving directions from I-5 northbound:** Take the Olive Way Exit (#166), and follow Olive Way uphill (it becomes E John Street). Turn left onto 15th Avenue E; go approximately 0.9 miles and turn left into Volunteer Park on E Galer Street. **From I-5 southbound:** Take the Boylston Avenue/Roanoke Street Exit (#168A) and turn left on E Roanoke Street. Take the first right onto 10th Avenue E and then the third left onto E Boston Street. Keep right at the fork and continue onto 15th Avenue E. Turn right into the park at E Galer Street.

Entrance to the Seattle Asian Art Museum

Lake View Cemetery (60)

If you are fond of visiting and photographing in old cemeteries, like I am, you may want to check out **Lake View Cemetery**, directly north of Volunteer Park. Founded in 1872, it is the final resting place of many of Seattle pioneers. You can find many familiar Seattle names here including Boren, Denny, Mercer, Yesler, Terry, Bell, and Maynard. Princess Angeline, daughter of Seattle namesake Chief Sealth, is interred here, as are martial-arts stars Bruce Lee and his son, Brandon Lee. The Lees' graves are a popular tourist destination and are often decorated with flowers, food, coins, and trinkets left by admiring fans. Most of the grave sites of the Seattle pioneers, as well as those belonging to the Lees, are near the top of the hill in the central portion of the cemetery.

For those looking for grave sites of famous Seattle residents, two of the city's most famous musicians are not actually buried in the city. Rock legend Jimi Hendrix was buried a short distance south of Seattle in Renton. The Jimi Hendrix Memorial is in the Greenwood Memorial Park, at 350 Monroe Avenue NE, Renton, Washington. The cemetery is open daily from dawn to dusk.

Nirvana lead singer Kurt Cobain was cremated. His ashes were reportedly (depending on the information source) spread over the Puget Sound, placed in McLane Creek in Olympia, Washington, tossed to the wind in Aberdeen, Washington (his hometown), or spread over the Wishkah River near Aberdeen. According to seattlechatclub.org, Lakeview Cemetery refused Kurt Cobain's ashes, stating they already had their hands full with Bruce and Brandon Lee and couldn't take another celebrity. The park benches in Viretta Park in Seattle, covered with graffiti messages to Cobain, who lived next door to the park, serve as de facto memorials. The park is at the foot of E John Street at 39th Avenue E and has an official address of 151 Lake Washington Boulevard E.

Hours

The cemetery is open daily, 9 a.m. to dusk.

Location and directions

Address: 1554 15th Avenue E.
Driving directions: Follow the directions for Volunteer Park on page 87 except do not turn on E Galer Street; the cemetery is immediately north of the park.

Northwest African American Museum and Jimi Hendrix Park (61 & 62)

The **Northwest African American Museum** (61) and **Jimi Hendrix Park** (62) sit side by side in the heart of Seattle's Central District. The museum, which opened in 2008, celebrates the black experience in America while, according to its website, exploring the connections between the Pacific Northwest and the history, art, and culture of people of African descent. The museum is housed in an old school building, and on clear days has views of Mount Rainier and the downtown skyline. There is always something new at the museum, with several temporary exhibits rotating through. In addition to the exhibits, there is a reading room and a genealogy center. Past exhibits

Flowers left on the grave of Bruce Lee

Museum guest viewing artifacts at the Northwest African American Museum, *photo by Jennifer Richard, courtesy of the Northwest African American Museum*

included the self-explanatory *Pitch Black: African American Baseball in Washington*; *Making a Life, Creating a World: Jacob Lawrence and James W. Washington*—featuring the artwork of two artists that helps shaped the Pacific Northwest's cultural landscape; and *The Product: Black Life in Hanford, WA*, an exhibit using declassified photographs to explore black life at Hanford, Washington, during the Manhattan Project.

Jimi Hendrix Park celebrates the life of one of Seattle's most famous musicians. The park, initially mostly an open field next to the museum, underwent a major renovation in 2015 following a vision to create a community space inspired by the life and music of Jimi Hendrix. Located in the neighborhood where Hendrix grew up, it includes a chronological timeline of the life of Jimi Hendrix, a "sound" wall, and a butterfly garden.

Hours

The Northwest African American Museum is generally open Wednesday–Sunday. It is open on Martin Luther King Jr. Day (when admission is by donation), Memorial Day, and Labor Day but closed on other major holidays. Open 11:00 a.m.–5:00 p.m., except on Thursdays when it is open until 7:00 p.m. Jimi Hendrix Park is open daily, 4:00 a.m.– 11:30 p.m.

Cost

Adult admission to the Northwest African American Museum is $7. Admission is free the first Thursday of each month.

Contact

Northwest African American website: www.naamnw.org; phone: 206.518.6000.

Location and directions

Northwest African American address: 2300 S. Massachusetts Street. **Jimi Hendrix Park address:** 2400 S Massachusetts Street. **Driving directions from I-5:** Exit to I-90 at Exit #164 (southbound) or #164A (northbound). Once on I-90, take Exit #3 to Rainier Avenue S and turn right on Rainier Avenue; shortly thereafter, turn right on S. Massachusetts Street; the museum and Jimi Hendrix Park will be on your left after three blocks.

PHOTOGRAPHY RESTRICTIONS

Photography for personal, non-commercial use is allowed in the museum. Flash photography and tripods are prohibited.

East Portal Viewpoint (63)

The **East Portal Viewpoint** is a small city park directly above Interstate 90 as it exits the Mount Baker Tunnel above Lake Washington. It has a view of the I-90 floating bridge, Lake Washington, downtown Bellevue, and the Cascade Mountains. The best light for photography is in the late afternoon, when western sun lights the bridge and mountains. It may be a good location for sunrise shots as well. Unfortunately, the view of the bridge is partially marred by a pole with a traffic camera.

Hours
The park is open daily, 6:00 a.m.–10 p.m.

Location and directions
Address: 1400 Lake Washington Boulevard S.

Driving directions from I-5: Exit to eastbound I-90 (toward Bellevue/Spokane). Once on I-90, take Exit #3 for Rainier Avenue S, turn right on Rainier Avenue S, and then take the first left onto S Massachusetts Street. At Martin Luther King Jr, Way S, turn left and cross under I-90. Then turn right onto S Irving Street. A block later, turn left onto Bradner Place S, then take the next right onto S Judkins St. At 32nd Avenue S, turn left and then left again back onto Irving Street. Finally, take the second right onto Lake Washington Boulevard S. The viewpoint will be on your left.

Driving directions from Seward Park: Drive north along the lake on Lake Washington Boulevard S. After approximately 3.2 miles, the main route (along the lake) becomes Lakeside Avenue S and Lake Washington Boulevard turns left. Turn left here to stay on Lake Washington Boulevard. The road wanders uphill through Colman Park and eventually continues north. After several blocks, the viewpoint will be on your right.

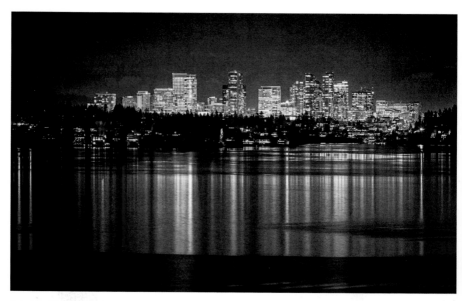

Lake Washington and the City of Bellevue from the East Portal Viewpoint

Madrona Park (64)

Along the Lake Washington shoreline, **Madrona Park** offers good views of Mount Rainier over the lake. The lakeside is a popular destination for locals on hot summer days for swimming and relaxing. The main body of the park (west of Lake Washington Boulevard) has a creek and hiking trails; the beach portion (east of Lake Washington Boulevard) stretches along the shore south of the main body of the park to a pleasure boat marina. The middle of the park's shoreline, just north of the parking lot, is a lifeguarded swimming area with a sandy beach. North of the sandy beach and south of the parking lot, grass runs to the shoreline and these areas are also sometimes used for swimming. Also south of the parking lot is an approximately 100-foot-long dock that goes out into the lake.

Hours

The park is open daily, 4:00 a.m.–11:30 p.m.

Location and directions

Address: 853 Lake Washington Boulevard.

Driving directions: There are several routes to the park, though perhaps the simplest is to follow the directions for East Portal Viewpoint (see page 90) then continue north on Lake Washington Boulevard S for 1.6 miles as it winds through Frink Park, eventually back to the lakeshore, and continues by Madrona Park. On a hot day, it may be difficult to find parking.

Marina on Lake Washington and Mount Rainier as viewed from the south end of Madrona Park

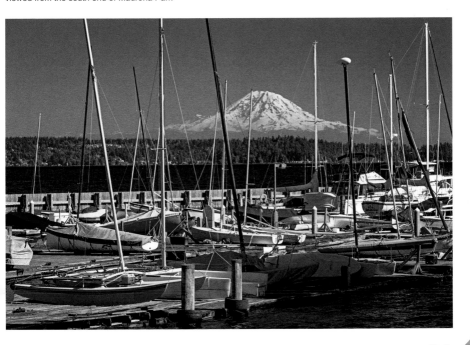

SOUTH MAGNOLIA HILL

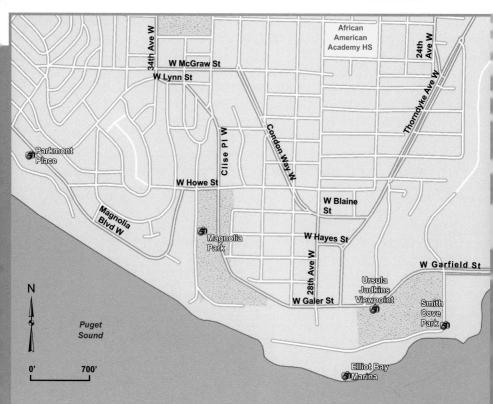

Magnolia Hill, northwest of downtown, is one of the seven hills of Seattle. The southern end of Magnolia Hill is mostly residential, but is also home to several impressive viewpoints.

Views from here include the Space Needle, downtown, Elliott Bay, West Seattle, Puget Sound, Mount Rainier, and the Olympic Mountains. The views of the Space Needle and downtown are unique, as these Magnolia viewpoints are less visited than the more popular views from Kerry Park and West Seattle. After visiting the southern part of Magnolia, you may wish to see the northern end, which is home to Discovery Park (see page 98), and also of interest. The northern portion of Magnolia is covered in the Northwest Seattle section.

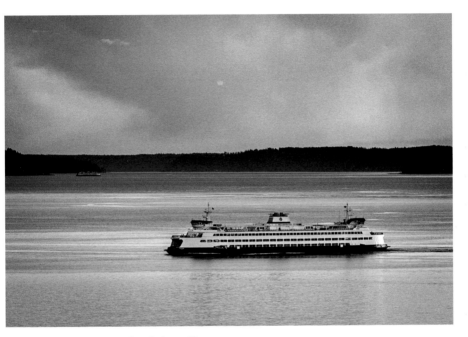

Ferries on Puget Sound viewed from Parkmont Place

Ursula Judkins Viewpoint (65)

The **Ursula Judkins Viewpoint** is close to downtown on the southeast corner of Magnolia Hill. The view from this point is not as widely known as many other Seattle viewpoints, but it is worth a stop if you are in the area. The best view here is of the Space Needle and the northern waterfront area. Though the main downtown area and the Central Waterfront are visible, they are partially obscured by a wire and trees. The view is generally best in the late afternoon when the western sun shines on the city, though sunrises may also be nice in the autumn when the sun rises behind the Space Needle. Other than the view, the park has no amenities.

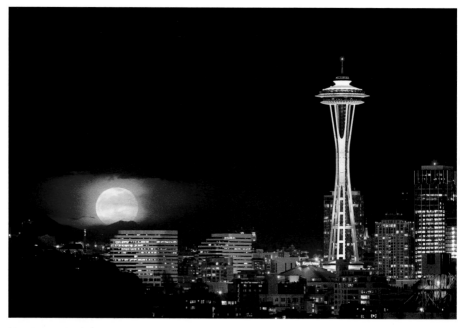

Moonrise and the Space Needle from Ursula Judkins Viewpoint

PHOTOGRAPHY TIPS

This is a good spot to photograph a rising full moon behind the Space Needle, which typically occurs in April or May each year. You can use a great program called The Photographer's Ephemeris to determine the exact date and time of the moon rise for this shot. The program is free when used on the Internet, or for a small fee as an Apple or Android app.

Hours

The park is open daily, 4:00 a.m.–11:30 p.m.

Location and directions

Address: Ursula Judkins Viewpoint does not have a street address but is south of the corner of W. Galer Street and Magnolia Way W, just west of the Magnolia Bridge.

Driving directions from I-5: Take the Mercer Street Exit (#167) and follow Mercer 1.6 miles to Elliott Avenue W. Turn right on Elliott, and in about 0.4 miles, take the exit ramp on the right toward W Garfield St./Magnolia Bridge. Continue across the Magnolia Bridge. At the west end of the bridge, turn left into the Ursula Judkins Viewpoint.

Magnolia Viewpoints (66 & 67)

On the southwest side of the Magnolia hill, two city parks offer great views of Puget Sound, ships and ferries, West Seattle, and the Olympic Mountains. **Parkmont Place** (66) is a long strip park along the Magnolia bluff with wide-open views to the west and southwest. It makes a nice place to take an evening stroll while taking in the view. From **Magnolia Park** (67), the view is more southerly and also offers a view of Mount Rainier. The view is more restricted in Magnolia Park because of numerous trees—though the madrona trees can, in themselves, make interesting photographic subjects. Madrona trees have orange, papery bark that naturally peels off to reveal greenish wood, reminiscent of eucalyptus trees. Parkmont Place has no amenities other than a walking path; Magnolia Park has a children's play area, picnic tables, and restrooms.

Hours
Magnolia Park and Parkmont Place are both open daily, 4:00 a.m.–11:30 p.m.

Location and directions
Address: Magnolia Park's address is 1461 Magnolia Boulevard W. Parkmont Place doesn't have an assigned address; however, there is a parking lot for the park on Magnolia Boulevard W between Montavista Place W and W Howe Street.

Driving directions from I-5: Follow the directions to Ursula Jenkins Viewpoint on page 94. After leaving the Magnolia Bridge, continue on the main route, which becomes W Galer Street and then Magnolia Boulevard W. Magnolia Park will be on your left. To get to Parkmont Place, continue on Magnolia Boulevard. At the end of Magnolia Park, turn left on W Howe Street and, a short distance later, continue left again onto Magnolia Boulevard. Parkmont Place will be along the left side of the road.

Westward view of aircraft carrier on Puget Sound and the Olympic Mountains from Parkmont Place

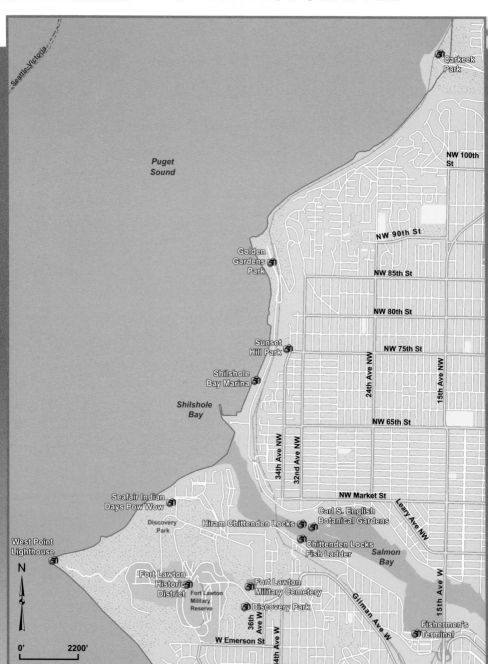

Seattle-Victoria

Puget
Sound

Carkeek
Park

NW 100th
St

NW 90th St

NW 85th St

Golden
Gardens
Park

NW 80th St

24th Ave NW

15th Ave NW

NW 75th St

Sunset
Hill Park

Shilshole
Bay Marina

*Shilshole
Bay*

34th Ave NW

32nd Ave NW

NW 65th St

NW Market St

Leary Ave NW

Carl S. English
Botanical Gardens

Seafair Indian
Days Pow Wow

Discovery
Park

Hiram Chittenden Locks

Chittenden Locks
Fish Ladder

Salmon
Bay

West Point
Lighthouse

N

Fort Lawton
Historic
District

Fort Lawton
Military
Reserve

Fort Lawton
Military Cemetery

Discovery Park

36th
Ave W

Gilman Ave W

15th Ave W

Fishermen's
Terminal

W Emerson St

34th Ave W

0' 2200'

Northwestern Seattle is a mixture of residential and commercial districts, but is also home to numerous parks—including Seattle's largest, Discovery Park. If you enjoy hiking, Discovery Park, which is mostly not accessible by car, is perhaps the best place inside the city limits to do it. Water is a major theme in this part of the city, with miles of fresh and saltwater shorelines. West of the Hiram Chittenden Locks is saltwater with Shilshole Bay and Puget Sound; east of the locks is fresh water with the Lake Washington Ship Canal, which connects Puget Sound with Lake Union and Lake Washington. Boat enthusiasts will enjoy northwestern Seattle, home to both the working boat hub of the city at Fishermen's Terminal and one of the largest pleasure boat harbors at the Shilshole Bay Marina. The commercial heart of the region is the neighborhood of Ballard, which has many fine restaurants to visit when your sightseeing is done.

Puget Sound sunset, Carkeek Park

Discovery Park (68–72)

At 534 acres, **Discovery Park** (68) is the largest park in Seattle. It sits atop the Magnolia bluff overlooking Puget Sound and occupies most of the site of former Fort Lawton. The park is full of photo opportunities for both natural and man-made subjects. There are two miles of Puget Sound beaches; there are sea cliffs, active sand dunes, meadows, forests, and streams. In the **Fort Lawton Historic District** (69) you can view former officers' quarters and other old military buildings. The park also is home to the **West Point Lighthouse** (70) (built in 1881 and still in use today), the **Fort Lawton Military Cemetery** (71), and the United Indians of All Tribe's Daybreak Cultural Center. The park hosts the annual **Seafair Indian Days Pow Wow** (72), a great venue for seeing Native American dancers and culture.[1] The Pow Wow is usually held in July.

According to the Seattle Parks Department, "the role of Discovery Park is to provide an open space of quiet and tranquility away from the stress and activity of the city, a sanctuary for wildlife, as well as an outdoor classroom for people to learn about the natural world." Therefore, most of the park is only accessible by foot or bicycle without a special permit. The roads that lead into the heart of the park require a permit for automobile travel. Other roads near the periphery are open to traffic and provide access to trailheads, parking lots, and the Daybreak Cultural Center. Permits are given first-come, first-served to park visitors physically unable to walk the 1.5 miles to the beach. Without a permit, the beach, the Fort Lawton Historic District, and the West Point Lighthouse can only be accessed by foot or bicycle. In addition to the roads, there are miles of trails, including a 2.8-mile loop trail through the park. The trails typically have little elevation gain except when nearing the beach where the trails drop off the bluff down to sea level.

PHOTOGRAPHY RESTRICTIONS

Commercial photography of the West Point Lighthouse requires a permit from the Seattle Parks and Recreation Department.

Concerning photography during the Indian Days Pow Wow, the United Indians Foundation states that etiquette requires asking permission from dancers in regalia prior to taking their photograph; if for publication or commercial use, mention this before taking photos. Group shots are "usually all right to take"; no photos are to be taken during veterans songs, flag songs, or prayers.

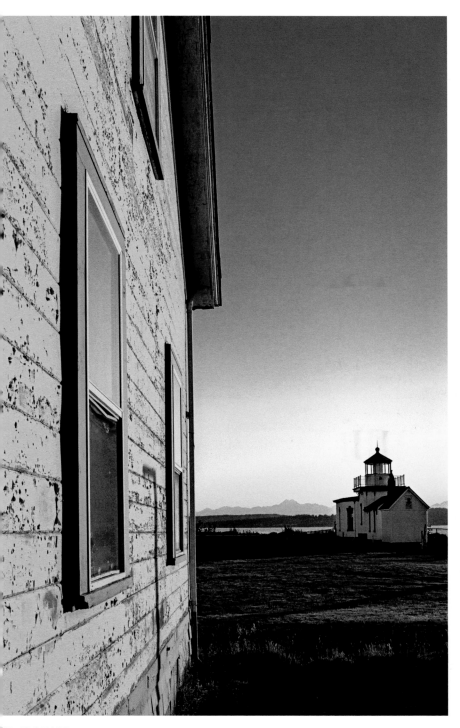

West Point Lighthouse

Park website: www.seattle.gov/parks/environment/discovery.htm; email: discover@seattle.gov; phone: 206.386.4236.

For Seattle parks photography permits, call 206.684.4081

For information on the annual Indian Days Pow Wow, contact the United Indians of All Tribes Foundation: www.unitedindians.org; info@unitedindians.org; 206.285.4425.

Location and directions

Address: Discovery Park Visitor Center: 3801 Discovery Park Boulevard.

Driving directions from northbound I-5: Take the Mercer Street Exit (#167). Several blocks later, turn right onto Westlake Avenue N, which eventually becomes W Nickerson Street. Continue straight on Nickerson Street past the Fremont Bridge. Stay in the left lane and follow signs to Ballard Bridge/Emerson Street. At W Emerson Street, turn left. Continue on Emerson through a stoplight to a four-way stop, and turn right onto Gilman Avenue W. Gilman becomes W Government Way. Government Way enters the park and becomes Discovery Park Boulevard. The Visitor Center will be on the left.

From southbound I-5: Take the NE 80th Street Exit (#172) and turn right onto NE 80th Street. After about 1.5 miles, at 15th Avenue NW, turn left and go over the Ballard Bridge. Take the first right after the bridge (onto W Emerson Street) and then right again onto Gilman Avenue W; Gilman becomes W Government Way, which enters the park.

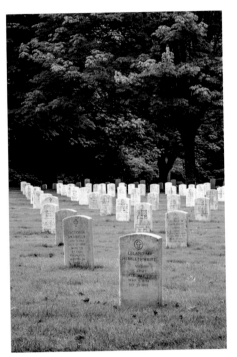

Fort Lawton Military Cemetery

Hours

Discovery Park is open daily, 4:00 a.m.–11:00 p.m. The visitor center is open non-holidays, Tuesday–Sunday, 8:30 a.m.–5:00 p.m.

Cost

Entry to the park is free. The Pow Wow has a $5 admission charge and a $15 charge for the salmon dinner.

Fishermen's Terminal (73)

The **Fishermen's Terminal** is home to the North Pacific Fishing Fleet. Operated by the Port of Seattle, the terminal is a great place to view the boats and activities of a commercial fishing harbor. The terminal serves more than 600 vessels, and though pleasure craft are docked there, preference is given to commercial fishing boats. The piers are open to the public, and you can easily wander with a camera for hours among the boats, looking at boat details and reflections. Also be sure to also look for nets and other gear stacked on shore. During the summer fishing season, there are fewer boats present than during the spring, when crews are preparing for the season, or during the fall and winter, when crews are working on their boats. If you happen by when a boat is off-loading fish, you can buy your dinner straight from the crew.

Fishing boat with floats,
Fishermen's Terminal

PHOTOGRAPHY TIPS

Telephoto zooms work well at Fishermen's Terminal for isolating details and reflections; wide-angle lenses can be used for wider views. For more of an aerial view, walk out on the west side of the Ballard Bridge and shoot back toward the terminal with a telephoto lens.

Hours
The terminal office is open Monday–Friday, 8 a.m.–4:30 p.m. The piers are always open.

Contact
Website: www.portseattle.org/Commercial-Marine/Fishermens-Terminal; email: ft@portseattle.org; phone: 206.787.-3395.

Location and directions
Address: 3919 18th Avenue W.
Driving directions from I-5: Follow the directions for Discovery Park on page 100, except once on W Emerson Street, turn right into the Fishermen's Terminal entrance at 18th Avenue W.

Hiram Chittenden Locks (74–76)

Lake Washington and Lake Union are connected via the Ship Canal to Puget Sound. The water level in the two lakes is about 20 feet above sea level. To maintain the elevation difference between the lakes and Puget Sound, and to prevent the mixing of fresh and salt waters, the US Corps of Engineers built the **Hiram Chittenden Locks** (74), also known as the Ballard Locks, in 1917. The locks complex includes one small and one big lock, a dam and spillway, and a fish ladder. The grounds are also home to an extensive botanical garden.

In addition to being interesting photographically, the locks, which are on the National Register of Historic Places, are fun to visit just to see how they work as a boat elevator. Free guided tours of the facility are available May 1 through September 30 as staffing permits (call the visitor center for tour times).

PHOTOGRAPHY TIPS

To photograph the locks, generally wide-angle to mild telephoto lenses work well for capturing the boats being raised and lowered. You can photograph from all sides of a boat when it is sealed in the locks and the water is being raised or lowered. Alternatively, you can capture the action with a wider view from the shore.

PHOTOGRAPHY TIPS

In the fish ladder, photographic conditions are difficult in the viewing area—the location is very dark, the glass is typically cloudy with algae, and the water can be cloudy. You will likely need a high ISO to capture a good image.

Boat in the Hiram Chittenden Locks

The **fish ladder** (75) is on the south shore. It is accessed by walking across the closed lock doors (one door on each lock is always closed) and traversing a walkway below the spillway. The fish ladder has underwater viewing windows to better see the fish. Most of the fish using the ladder are salmon and steelhead, and the best viewing times are dependent upon species. Chinook (or king) salmon use the ladder from July through November, with the best viewing in the second half of August. Coho (or silver) salmon use the ladder from August through November, with the best viewing time in late September. The sockeye salmon run lasts from June through October, with the height of the run in July. Steelhead (sea-run trout) typically run from November through May, with the best viewing in late February and early March.

Also worth a visit while at the locks is the **Carl S. English Jr. Botanical Gardens** (76). Carl S. English worked for the US Army Corps of Engineers at the locks for forty-three years following their construction. He built up the gardens with flowers and plants from around the world with the help of sea captains using the locks. Today, the gardens, built in a romantic English style, have more than 570 species and 1,500 varieties of plants.

Passion flower, Carl S. English Jr. Botanical Gardens

Hours

While the locks themselves are open to vessel traffic twenty-four hours a day, the grounds are only open 7:00 a.m.–9:00 p.m. The fish ladder viewing room closes at 8:45 p.m. The visitor center is closed on Tuesdays and Wednesdays; otherwise it's open 10:00 a.m.–6:00 p.m., May–September, and closes at 4:00 p.m. the rest of the year.

Contact

Information on the locks, fish ladder, and gardens can be found on the US Army Corps of Engineer website: www.nws. usace.army.mil/Missions/CivilWorks/ LocksandDams/ChittendenLocks.aspx. Visitor center phone: 206.783.7059.

Location and directions

Address: 3015 NW 54th Street is the address for the main entrance and parking lot for the locks. The main entrance is on the north side (in Ballard) of the ship canal. The locks can also be reached from Commodore Park on the south side (Magnolia) at 3330 W Commodore Way.

Driving directions to the main entrance in Ballard. From northbound I-5: Take Exit #169 for NE 45th Street and turn west on NE 45th Street. Stay on 45th as it becomes 46th Street and eventually NW Market Street all the way through the Ballard business district. Follow the main route as it bears left on NW 54th Street, and immediately turn left after the Lockspot Café.

From southbound I-5: Take Exit #172 for N 85th Street and merge onto 85th. Stay on 85th until it ends at 32nd Avenue NW. Turn left on 32nd Avenue, and follow it until it ends at NW 54th Street. Turn right onto 54th, then right again just before the Lockspot Café.

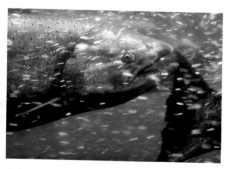

Salmon in the fish ladder at the Hiram Chittenden Locks

Carkeek Park (77)

Carkeek Park has more than 200 acres of forest, meadows, creeks, and beach, along with great views of Puget Sound and the Olympic Mountains. If you visit in November or December (generally best from the third week of November through the second week of December), you also have the chance to see chum and coho salmon returning to Piper Creek. This is not a large fish run (the Washington State Department of Fish and Wildlife places the run at less than 1,000 spawners). However, it may be the only place in the city to see returning salmon other than at the Chittenden Locks fish ladder. If you are interested in salmon viewing, there are many salmon viewing sites elsewhere in King County and western Washington (see wildfishconservancy. org/resources/view-wild-salmon-steelhead).

PHOTOGRAPHY TIPS

Photographing salmon can be a challenging but fun experience. The fish can be difficult for the camera to see in the water, and low light conditions are common. Use a polarizer to cut glare off the water's surface to better see the fish.

Puget Sound and the Olympic Mountains from Carkeek Park

Hours
The park is open daily, 6:00 a.m.–10 p.m.

Contact
Park website: www.seattle.gov/parks/ environment/carkeek.htm; phone: 206.684.0877.

Location and directions
Address: 950 NW Carkeek Park Road. **Driving directions from I-5:** Take Exit #173 to Northgate Way and turn west. Northgate Way eventually becomes N 105th Street. Turn right onto Greenwood Avenue N and left onto NW 110th Street. After six blocks, NW 110th becomes NW Carkeek Park Road, which winds down to the park entrance.

NORTH OF LAKE UNION

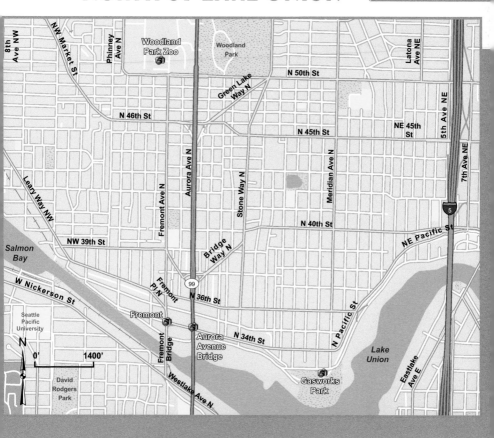

Lions, Woodland Park Zoo

The north-central portion of Seattle, north of Lake Union, gives visitors and photographers several interesting options. Directly on the northern shore of Lake Union is the very popular, and photographically varied, Gasworks Park. Animal lovers will enjoy a visit to Woodland Park Zoo, home to more than 300 species of animals. And those who like funky neighborhoods will definitely want to visit Fremont, the self-proclaimed "Center of the Universe."

Gasworks Park (78)

Gasworks Park is on the northern shore of Lake Union. The park gives photographers a wide variety of opportunities. It has a panoramic view of downtown Seattle, colorful old machinery, the remains of an old gas plant, and views of seaplanes taking off and landing, as well as some of the famous Seattle houseboats. The 20-acre park was originally the site of an industrial plant that made gas from coal. The plant was closed in the 1950s and the city opened the park in 1975. The legacy of the park's industrial past lives on today, not only in the machinery left behind, but also in contaminated sediments on the lakeshore (entering the water at the park is prohibited).

A large portion of the old gas plant remains in the middle of the park. This area is fenced off, but you can circle it for a good look at the park's industrial past. Nearer the parking lot, the former exhauster-compressor building has been converted into a covered but open-sided "play barn." It is full of colorfully painted machinery. Look south over Lake Union from the park for a panoramic view of downtown Seattle. There are two seaplane bases on southern Lake Union, making Gasworks Park an excellent place to watch planes take off and land. Though a bit distant from the park, you can see a good selection of Seattle's houseboats along the east and west shores of the lake (the one made famous in the movie *Sleepless in Seattle* is on the western shore of the lake, southwest of the park).

PHOTOGRAPHY TIPS

Gasworks Park gives photographers many options. Look for interesting compositions among the pipes, ductwork, ladders, metal walkways, and other industrial fixtures in the remains of the old gas plant. A 70-200mm zoom lens works well here to isolate details and keep the fence out of the picture. The colorful machinery in the play barn makes interesting subjects and compositions. Wide-angle to mild telephoto lenses work well in this area. The park is a good spot to take panoramic shots of the city skyline; try taking several shots and stitch them together. The best light for shooting the skyline will be in early morning, late afternoon, or at night when you can get city lights reflecting off the lake. When the seaplanes are taking off, try isolating one against the Seattle skyline with a telephoto lens.

Hours

The park is open daily, 6:00 a.m.–10 p.m.

Location and directions

Address: 2101 N Northlake Way.
Driving directions from I-5: Take Exit #169 for NE 45th Street. Turn west on NE 45th Street. After approximately 0.5 mile, turn left on Meridian Avenue N, which ends at the park. Turn right onto N Northlake Way, then left into the park's parking lot.

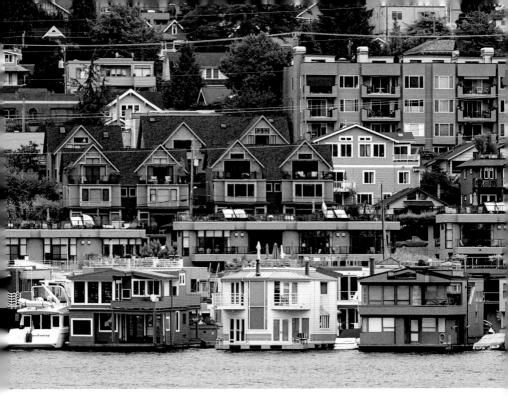

Houseboats on Lake Union as viewed from Gasworks Park

Old gas plant, Gasworks Park

Fremont (79 & 80)

Fremont (79) is a funky little neighborhood in north Seattle, self-proclaimed as the "Center of the Universe." There's always something fun happening in Fremont. A street market that includes crafts, antiques and collectibles, and imports, as well as produce, is held every Sunday year-round. Fremont has monthly artwalks (first Fridays); and a host of festivals, including the Moisture Festival (comedy/varieté festival), the Fremont Fair and Solstice Parade (famous for the Solstice Cyclists, who ride their bicycles in the parade wearing only body paint and shoes), the annual Zombie Walk (an annual flash mob of zombies), the HopScotch festival (beer and scotch), the Northwest Lovefest (music and arts), the Fremont Oktoberfest, and more. The district also is home to a large number of fun art pieces. These include the *Fremont Troll*[1] (rising out of the ground to capture a VW Beetle), *Lenin* (a larger than life statue of Vladimir Lenin), *Waiting for the Interurban* (an interactive statue of life-size people and a dog [with a human face] dressed for every occasion), a 53-foot-tall Cold War–era rocket, and much more. Fremont is definitely worth walking around for a few hours, camera in hand. You never know what you will see.

When visiting the *Fremont Troll*, you may also want to take a quick trip up to the **Aurora Avenue Bridge** (80) for a view of Lake Union, downtown Seattle, and Mount Rainier. The Aurora Avenue Bridge crosses the northwestern end of Lake Union where the lake merges into the Fremont Cut (the portion of the Lake Washington Ship Canal that connects Lake Union to the eastern end of Salmon Bay). On a sunny day, the view from the bridge over Lake Union toward downtown Seattle is spectacular. The lake is often filled with boats of all sizes, and Mount Rainier seems to tower over the city. While the view is fantastic, the location is not. The bridge has six narrow lanes of traffic, and though the speed limit is 40 miles per hour, the speed limit is rarely obeyed. There are narrow sidewalks on both sides, separated from the traffic by short walls with low hand railings. The outsides of the sidewalks have slightly higher railings and suicide-prevention fences made of thick cables. These cable fences give the experience of being caged in with the speeding traffic only a few feet away.

The formal name of the Aurora Avenue Bridge is the George Washington Memorial Bridge, though I doubt many Seattleites know it by that name. To access the bridge, walk up the stairs on the right-hand side of the *Troll*. At the top of the stairs, turn left and walk out onto the bridge.

PHOTOGRAPHY RESTRICTIONS

Many of the art pieces are copyrighted and photographs cannot be used commercially without permission.

Helping protect Fremont from stray bugs, *The Troll* ©
1990 Badanes, Martin, and Whitehead

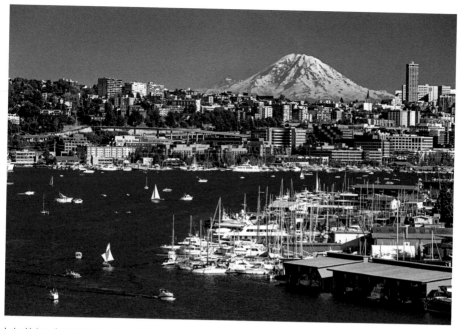

Lake Union, downtown Seattle, and Mount Rainier from the Aurora Street Bridge

PHOTOGRAPHY TIPS

The view from the Aurora Street Bridge is not easy to shoot with a DSLR because of the cable fencing, though it is fine with a smaller camera. Typical DSLR lenses will fit through the cables, but only at a 90 degree angle from the bridge, and the best view is at a 30 to 45 degree angle. You may need to physically push the cable aside with your lens barrel—so look for a spot where the gap between the cables is larger than average. And forget about using a tripod. The whole bridge vibrates with the traffic.

Contact

The Fremont Chamber of Commerce website, Fremont.com, has a downloadable walking guide and a calendar with all Fremont events. Phone: 206.632.1500.

Location and directions

Address: The main Fremont business area is centered on Fremont Avenue N, just north of the Fremont Bridge, between N Northlake Way and N 36th Street.

Driving directions from I-5: Take Exit #169 for NE 45th Street. Turn west on NE 45th Street and continue a short mile to Stone Way N. Turn left on Stone Way. Turn left on either N 34th or 35th Streets; both will take you into the heart of Fremont. The *Troll* is east of "downtown" Fremont at the intersection of N 36th Street and Troll Avenue N, directly underneath the Aurora Bridge.

Woodland Park Zoo (81)

The **Woodland Park Zoo** is just north of Fremont (in the Phinney Ridge neighborhood) The award-winning zoo has approximately 1,100 animals representing 300 species What makes this zoo special, and good for photography, is that most of the animals are presented in natural-like settings. In fact, according to the zoo's website, the Woodland Park Zoo was a leader in creating naturalistic exhibits, opening the first such exhibit for gorillas in August of 1979. The zoo is organized into ecosystem areas including the Tropical Rain Forest (with jaguars, poison arrow frogs, toucans bushmasters, lemurs, gorillas, and monkeys), the African Savanna (zebras, giraffes gazelles, hippos, lions, and patas monkeys), the Northern Trail (gray wolves, grizzly bears, mountain goats, arctic foxes, bald eagles, and elk), the Trail of Vines (a tropical Asian exhibit with macaques, tapirs, pythons, siamangs, and orangutans), and Australasia (kookaburras, parrots, wallaroos, and snow leopards). There is also a Family Farm, Bug World, and a Raptor Center.

PHOTOGRAPHY TIPS

The zoo is very popular, and you may have trouble using a tripod at some of the more popula exhibits. By going early in the day, or on cold or rainy days, you may be able to beat some o the crowds.

PHOTOGRAPHY RESTRICTIONS

There are no restrictions on photography for personal use. And while a permit is required fo large-scale commercial photo shoots, the zoo does not require a special permit for commercia photography involving a single photographer without special equipment. The zoo does asl that photographers respect other visitors and their ability to see the animals.

Hours

Open daily, 9:30 a.m.–6:00 p.m., May–September; and 9:30 a.m.–4:00 p.m., October–April. Closed on Christmas.

Cost

Adult tickets are $19.95, May–September, and $13.75 the rest of the year. The zoo is also available as part of the CityPASS. Parking costs $5.25 per day.

Contact

Website: www.zoo.org; email: zooinfo@zoo.org; phone, 206.548.2500.

Location and directions

Address: The south entrance is at 750 N 50th Street; the west entrance is at 5500 Phinney Avenue N.
Driving directions from I-5: Take the NE 50th Street Exit (#169). Turn west on 50th Street and travel 1.3 miles to the south entrance at the corner of 50th Street and Fremont Avenue N.

Pete, one of the silverback gorillas at Woodland Park Zoo

SOUTH SEATTLE

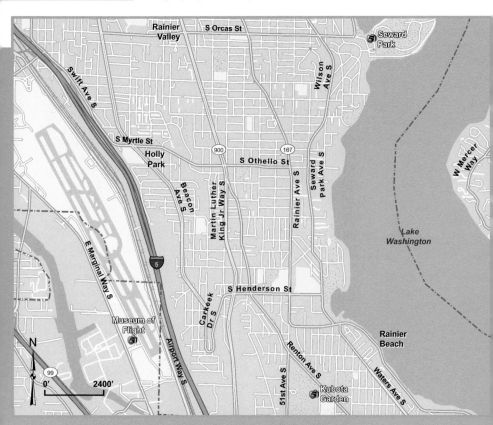

Rainier
Valley

S Orcas St

Seward
Park

Swift Ave S

Wilson
Ave S

W Mercer
Way

S Myrtle St

Holly
Park

900

S Othello St

167

Beacon
Ave S

Martin Luther
King Jr Way S

Rainier Ave S

Seward
Park Ave S

Lake
Washington

E Marginal Way S

5

S Henderson St

Carkeek
Dr S

Airport Way S

Museum of
Flight

N

Renton Ave S

Rainier
Beach

Waters Ave S

99

0' 2400'

51st Ave S

Kubota
Garden

South Seattle is a mix of industrial areas
concentrated in the Duwamish Valley west of
Interstate 5 and residential areas on the hills east of
Interstate 5. However, the area does contain several
areas of special interest. For airplanes and spacecraft
enthusiasts, the Flight Museum at Boeing Field offers
a fun place to visit. The largest and most scenic park
on Lake Washington, Seward Park, is in the area. For
lovers of gardens, perhaps the best garden in the city,
Kubota Garden, is also in south Seattle.

Autumn at the Kubota Garden

Seward Park (82)

The Bailey Peninsula, which sticks out like a sore thumb into Lake Washington, forms **Seward Park**. The 300-acre park contains over two miles of shoreline, 120 acres of old growth forest, and many trails and paths, including a paved bike/walking path along the peninsula's shoreline. The forest is the largest stand of old trees inside the city limits. Though too small to be home to any large wildlife, the forest and shoreline are home to many birds including bald eagles and hawks, great blue herons, loons, and other waterfowl. The south and east sides of the peninsula offer views of Mount Rainier. Areas along the northern shoreline offer photogenic, natural lily-pad gardens. The road through the park winds uphill from the park entrance to the center of the peninsula, providing access to the forest without having to hike uphill.

Hours

The park is open daily, 6 a.m–10 p.m.

Contact

Seattle Parks website: www.seattle.gov/parks/environment/seward.htm; park phone: 206.684.4396. Friends of Seward Park website: www.sewardpark.org; email: sewardparkfriends@gmail.com.

Location and directions

Address: 5895 Lake Washington Boulevard S.
Driving directions from northbound I-5: Take the Swift Avenue Exit (#161) towards Albro Place. Turn right on Swift Avenue S and take the first left onto S Eddy Street.

After three blocks, turn left onto Beacon Avenue S and after 0.4 miles, turn right on S Orcas Street. Continue on Orcas for two miles, and Orcas eventually becomes Lake Washington Boulevard S. The park entrance will be on your left.
From southbound I-5: Take Exit #163A for Columbian Way. Keep left at the fork on the exit ramp and merge onto Columbian Way S. Columbia Way merges with 15th Avenue S. After about 0.4 miles, make a slight left back onto S Columbian Way. After 0.5 miles, turn right onto Beacon Avenue S, and after another 0.6 miles, turn left onto S Orcas Street then follow the directions above.

Shore of Lake Washington, Seward Park

Kubota Garden (83)

Kubota Garden is an amazing 20-acre city park that combines Japanese and Northwest gardening styles. Fujitaro Kubota, a self-taught gardener, started the garden in 1927 and expanded it as his landscaping business grew. The garden was his home as well as his business design and display center. In the early 1980s, when the garden was targeted for condominium development, community groups rallied to save it by having it declared a historic landmark of the City of Seattle. Later, in 1987, the Kubota family sold the garden to the city to preserve it for public use.

The garden features streams, ponds, waterfalls, rock outcrops, two Japanese bridges, a Japanese bell, and a lovely Japanese entry gate. Though it is worth the time to wander through the whole garden, my favorite spots are the Moon Bridge, a traditional, red-arched Japanese bridge, and the Tom Kubota Stroll Garden, an open garden space designed and built by Fujitoro's son in 1999 and filled with color in the spring. A pamphlet offering a self-guided tour through the garden is available at the Kubota Garden Foundation website. The best times of year to visit are in April or May for peak color from the multiple azalea and rhododendron blooms, or in October for fall color.

PHOTOGRAPHY RESTRICTIONS

For professional photography, a permit is required from Seattle Parks. Permits cost $25 for Mondays through Thursdays and $200 for Fridays through Sundays.

Hours

The park is open daily, 6:00 a.m. to 10 p.m.

Contact

Kubota Garden Foundation website: www.kubotagarden.org; phone: 206.725.5060. To request a professional photography permit, call Seattle Parks at 206.684.4081.

Location and directions

Address: 9817 55th Avenue S.

Driving directions from northbound I-5: Take Exit #158 toward Martin Luther King Jr. Way, keep right at the fork and merge onto Martin Luther King Jr. Way S. At S Ryan Way, turn right. Turn left on 51st Avenue S, right on Renton Avenue S, and right again onto 55th Avenue S. The garden's parking lot will be on your right.

From southbound I-5: Take Exit #157 for Martin Luther King Jr. Way and stay on Martin Luther King Jr. Way until S Ryan Way. Turn right on Ryan Way, then follow the directions above.

Tom Kubota Stroll Garden portion of Kubota Garden

Museum of Flight (84)

In addition to being the Emerald City, Seattle is also informally known as the Jet City. Aircraft have been integral to the development of Seattle since Boeing opened its doors for business in Seattle in the early 1900s. Today, Seattle is the home to the **Museum of Flight**, the largest private air and space museum in the world.[1] The museum is dedicated to preserving and exhibiting historically significant air- and spacecraft and artifacts for both scholarly research and educating the public. It contains more than 150 aircraft, and if you have any interest in aviation, this is a must-see Seattle attraction. And luckily, it also holds many photographic opportunities. The museum is very popular; so to avoid crowds, you may wish to go early in the day and/or on weekdays.

The Museum of Flight is at the King County International Airport, better known as Boeing Field. The airport was opened in 1928 as a test and delivery facility for the Boeing Company, and also served as Seattle's passenger airport. Passenger services moved to the Seattle-Tacoma International Airport in the 1940s, but Boeing Field continues to be used by the Boeing Company, as well as general aviation and cargo companies. The museum offers Boeing Field runway tours on Saturdays and Sundays for an extra fee.

The museum is made up of four separate buildings and an outside airpark. The largest, and main, building is known as the Great Gallery. It currently contains thirty-nine full-sized aircraft in a six-story glass-and-steel exhibition hall. These include a Blackbird, a German "Buzz Bomb," a Coast Guard helicopter, a Vietnam-era Huey, and a nine-ton Douglas DC-3. Most of the planes hang from the ceiling, appearing as if in flight.

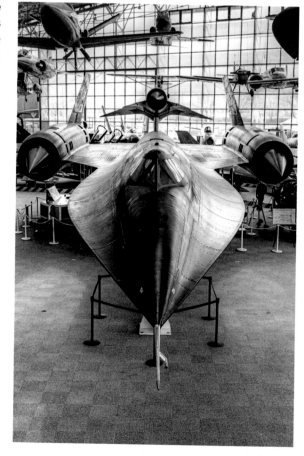

Lockheed Blackbird M-21 in the Great Gallery, Museum of Flight

PHOTOGRAPHY TIPS

Because the Great Gallery is constructed with a large glass ceiling and walls, it is flooded with light during the day. While providing good light for photography, the glass can cause severe contrast problems for image compositions that include the glass walls and ceiling. This problem can be solved by using careful composition to minimize the amount of the walls and ceiling in the frame, using HDR techniques, or by photographing at night. Indeed, because of dramatic lighting, night may be the best time to photograph here. In contrast to the Great Gallery, the Personal Courage Wing has no windows and is fairly dimly lit. A tripod is extremely handy here; and you may wish to consider HDR. The eastern wall of the Space Gallery is glass, providing good illumination for some exhibits. In addition to the exhibits in the buildings, the Memorial Bridge in itself is photogenic and can make good abstracts.

PHOTOGRAPHY RESTRICTIONS

Tripods are not allowed inside the planes in the airpark. Flash photography is generally allowed except where posted. Video and commercial photography are prohibited.

The second building contains the Personal Courage Wing, which presents the story of fighter aviation with twenty-eight restored, full-size fighter planes displayed on two floors—the lower floor dedicated to World War II and the upper floor to World War I. In addition to American planes, the Personal Courage Wing includes German, Japanese, and Russian aircraft.

The third and smallest building is the William E. Boeing Red Barn. This was the original Boeing Company's manufacturing plant and features the story of the Boeing Company from 1916 through 1958.

The fourth building houses the Charles Simonyi Space Gallery. It is accessed by the Memorial Bridge, a footbridge across the road from the other three buildings. Visitors crossing the bridge enjoy a collection of sounds from aviation history. The main exhibit in the Space Gallery is the NASA Space Shuttle Trainer—a full-size mockup of the space shuttle formerly used by NASA to train astronauts. Visitors are allowed access into the cargo area of the trainer, or into the crew and pilot sections by paying for a special tour.

The airpark is outside, north of the Space Gallery. Here you can walk through the Air Force One used by presidents Eisenhower, Kennedy, Johnson and Nixon, as well as a British Airways Concorde SST. The other planes in the airpark, including the first Boeing 737 and 747 to come off the assembly lines, are open for tours only during special events.

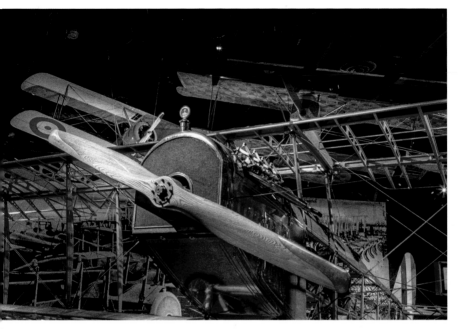
Curtiss JN-4D Jenney in the Personal Courage Wing, Museum of Flight

Hours

The Museum of Flight is open daily (except for Thanksgiving and Christmas), 10:00 a.m.–5:00 p.m. (until 9:00 p.m. on the first Thursday of each month). The airpark is open 11:00 a.m.–4:00 p.m.

Cost

Adult general admission is $20. There is free admission the first Thursday of each month between 5:00 and 9:00 p.m. The special tours cost $20 to $30 extra.

Contact

Website: www.museumofflight.org; phone: 206.764.5700; email: info@museumofflight.org.

Location and directions

Address: 9404 East Marginal Way S.
Driving directions from northbound I-5: Take Exit #158 (Airport Way/E Marginal Way). Cross the freeway and turn right on East Marginal Way. The museum will be approximately ¾ mile farther on the right.
From southbound I-5: Take Exit #161 (Albro Place). Turn right off the exit onto S Albro Place and continue onto Ellis Avenue S. After half a mile, turn left onto East Marginal Way. The museum will be on your left just shy of 2 miles.

WEST SEATTLE

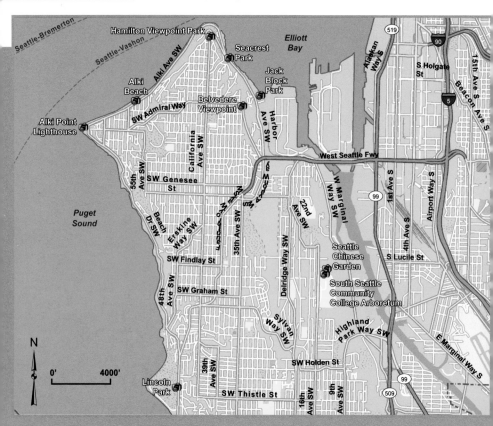

West Seattle is the Seattle neighborhood across
Elliott Bay from downtown. A former independent
town (annexed in 1907), and separate from the
rest of the city, West Seattle has its own unique
identity. Photography-wise, the neighborhood has
great views of the city skyline, Puget Sound, and
the Cascade and Olympic Mountains. There are
many saltwater-beach parks in West Seattle. For
many people, the major draw here is Alki Beach
Park—which forms the entire northwestern
shoreline of the West Seattle peninsula.

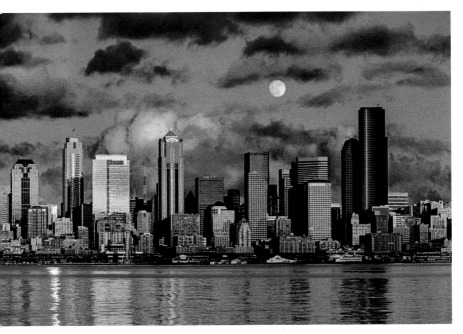

Moonrise over downtown Seattle as viewed from Seacrest Park

Harbor Avenue Parks (85 & 86)

There are a number of viewpoints along Harbor Avenue on the Elliott Bay shoreline of West Seattle. At the southern end is **Jack Block Park** (85), operated by the Port of Seattle. This little known park is rarely if ever crowded. It provides views of Elliott Bay and the Seattle skyline to the north and industrial port operations to the south. The park features a pier and a 45-foot-tall observation tower, as well as access to the beach.

Further north along Harbor Avenue is **Seacrest Park** (86), run by the Seattle Parks Department. The park stretches between the east side of Harbor Avenue and the shoreline for a couple thousand feet. At the northern end of the park (before the road turns westward onto Alki), you are almost directly west of downtown Seattle. This spot provides one of the best views of the Seattle skyline in the city. The Bainbridge Island and Bremerton ferries steam past West Seattle, so this is a great spot to photograph ferries, particularly with the city in the background. There is even a view of Mount Rainier to the south. Near the southern end of the park is a water taxi dock and a fishing pier. The water taxis sail from Seacrest Park to downtown Seattle on weekday mornings (generally between 6:00 and 9 a.m.) and afternoons (4:00 to 7:00 p.m.) only.

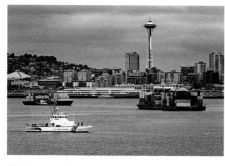
Elliott Bay and the Space Needle from Jack Block Park

Location and directions

Jack Block Park address: 2130 Harbor Avenue SW. It is fairly easy to miss the entrance as you drive north along Harbor Avenue, so pay close attention.
Driving directions from I-5: Take Exit #163 (from the south) or #163A (from the north) to West Seattle. After crossing the West Seattle Bridge, take the Harbor Avenue SW exit and turn right onto Harbor Avenue. After 0.9 of a mile, turn right onto SW Florida Street.

Seacrest Park address: 1660 Harbor Avenue SW. This is the location of the fishing pier and water taxi. Most of the park is north of this spot along the water.
Driving directions: Follow the directions for Jack Block Park, but continue straight on Harbor Avenue rather than turning on Florida Street. The park will be on your right along the shoreline.

Hours

Jack Block Park is open daily, 6:00 a.m.–9:00 p.m. The park gate is locked at closing time. Though not gated, Seacrest Park is officially open daily, 4:00 a.m.–11:30 p.m.

Mount Rainier from Seacrest Park

Alki Beach (87 & 88)

When most Seattleites think of West Seattle, they think of **Alki Beach** (87). Alki Beach runs along the entire northwest shoreline of the West Seattle peninsula, from Duwamish Head (the northernmost point in West Seattle) to Alki Point (the westernmost point in all of Seattle), a distance of about 2.5 miles. Alki Beach was where the first non-native Seattleites lived when Arthur Denny and his party of white settlers landed on the beach in November 1851 and founded the city.

Today, the beach is all public property and is part of the park. The northern portion of the beach is protected by a bulkhead, and during high tide, water usually comes up to the bulkhead. However, there is a walking path adjacent to the bulkhead, providing views even when the water is high. The beach offers views of the Olympic Mountains, downtown Seattle, and ferries. It is also a great place for people-watching, especially during the summer when people from across the city flock there for sunbathing, skating, jogging, and just hanging out.

About midway down the beach along the walkway is one of the beach's two main landmarks: a small replica of the Statue of Liberty, donated by the Boy Scouts in 1952. Across from the beach near the Statue of Liberty is the main business district along Alki, with many restaurants, shops, and art galleries.

The other main landmark is the small, photogenic **Alki Point Lighthouse** (88), at the far western end of the beach. The lighthouse grounds are not part of the park, but rather are owned by the US Coast Guard. The grounds are only open during tour hours (generally only on summer weekends), but photos of the lighthouse can be made from the beach during low tides. However, for the best views, you need to visit the grounds. The tours are free.

Hours

Alki Beach Park is open 4:00 a.m.–11:30 p.m. Alki Point Lighthouse is open for tours on Saturdays and Sundays, 1:00–4:00 p.m., Memorial Day through Labor Day. Special tours can sometimes be arranged for groups.

Contact

For more information on the Alki Point Lighthouse, email the Alki Lighthouse public officer at alkilighthouse@cgauxseattle.org.

Location and directions

Alki Beach Park address: 1702 Alki Avenue SW.
Driving directions: To reach the park, follow the directions to the Harbor Avenue parks (see page 120). Harbor Avenue, which runs north, curves west at Duwamish Head and becomes Alki Avenue SW. The park is along the northern side of Alki Avenue.

Alki Point Lighthouse address: 3201 Alki Avenue SW. **Driving directions:** To reach it, continue west on Alki Avenue until the the road makes a left-hand turn on the tip of Alki Point (Alki Avenue is an arterial until 63rd Avenue SW, where the arterial turns left onto 63rd; continue past this point on Alki Avenue, where it becomes a residential street). The lighthouse grounds will be on your right.

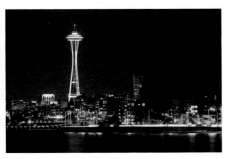

Space Needle from Alki Beach

Belvedere Viewpoint (89)

For a more elevated view of the city than you can get from Harbor Avenue, try the **Belvedere Viewpoint**. The view extends past the city to the Cascade Mountains and Mount Rainier. The park also contains a historic totem pole.

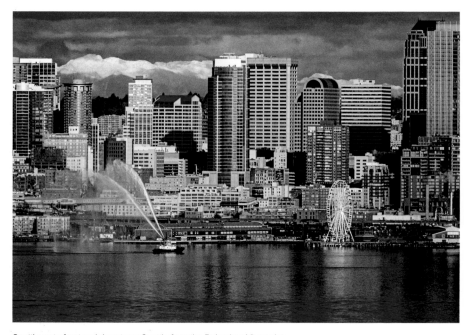

Seattle waterfront and downtown Seattle from the Belvedere Viewpoint

PHOTOGRAPHY TIPS

Trees near the viewpoint block part of the view of Elliott Bay. If you don't want the trees in your composition, consider using a telephoto lens to create a tighter composition. Also, though more elevated than Harbor Avenue, this viewpoint is a bit more distant. Once again, using a telephoto lens can help.

Hours

The viewpoint is within Belvedere Park, which is open 4:00 a.m.–11:30 p.m.

Location and directions

Address: 3600 SW Admiral Way.
Driving directions from I-5: Take Exit #163 (from the south) or #163A (from the north) to West Seattle. After crossing the West Seattle Bridge, exit onto SW Admiral Way. Near the top of the hill, as the road turns left, the viewpoint will be on your right.

Lincoln Park (90)

Lincoln Park is the largest park in West Seattle, encompassing 135 acres. It is on the shores of Puget Sound, just north of the Fauntleroy Ferry Terminal. In addition to rocky beaches loaded with driftwood and views of the ferries and Olympic Mountains, there are grassy meadows and forests. Bald eagles and osprey are often seen in the area. There are trails along the beach, as well as through the forested areas. Of particular photographic interest, to me at least, are the madrona trees in the park with their rich red-orange, peeling bark revealing greenish, satiny wood underneath. They are a uniquely Pacific Northwestern tree, growing only from Northern California through British Columbia, and only close to saltwater. Though found throughout Seattle, the madronas in Lincoln Park are some of the best examples around. The park also features an outdoor heated saltwater swimming pool.

Madrona tree and ferry on Puget Sound, Lincoln Park

PHOTOGRAPHY TIPS

When photographing in Lincoln Park, the madrona trees can be used as compositional elements in shots of forest, as framing elements for views of Puget Sound, or as interesting subjects in their own right.

Hours
The park is open daily, 4:00 a.m.–11:30 p.m.

Location and directions
Address: 8011 Fauntleroy Way SW. There are two parking lots at the park; the address is by the northern of the two lots (near the center of the park). The other lot is also on Fauntleroy Way at the southern end of the park.
Driving directions from I-5: Take Exit #163 (from the south) or #163A (from the north) to West Seattle. Continue on the main route after crossing the West Seattle Bridge, which eventually turns into Fauntleroy Way SW. After several miles, the park will be on your right.

Seattle Chinese Garden and
South Seattle College Arboretum (91 & 92)

The Seattle Chinese Garden (91) is one of the newer and lesser-known attractions in the city. It is a work in progress, and currently consists of a beautiful Chinese courtyard, built in 2010, and a neighboring garden and small pond. When completed, it will include several larger ponds and waterfalls and nine pavilions, including the Floating Cloud Tower, a four-story Chinese tower overlooking the harbor and downtown Seattle. According to the garden's website, it is the first Sichuan-style garden in the United States and, at 4.6 acres, one of the largest Chinese gardens outside China. The garden was designed and is being built by collaborating architects and artisans from Seattle and Seattle's sister city, Changqing, China. A tour and plant guide is available in the courtyard.

The garden is on the campus of South Seattle Community College, adjacent to the college's **arboretum** (92). The 5-acre arboretum includes a number of gardens including a rock garden, two rose gardens, a sensory garden, a dwarf conifer garden, a sequoia grove, a dahlia grove, and more.

Looking out of the courtyard at the Seattle Chinese Garden

Path in the South Seattle Community College Arboretum

Hours

The Seattle Chinese Garden and South Seattle Community College Arboretum are open daily, dawn to dusk, though intermittent closures may occur in winter during inclement weather. The courtyard in the Chinese garden has seasonal hours and may be closed in the early morning and late evening.

Cost

Both the garden and arboretum are free to visit, but there is a $3 fee to park on the college campus.

Location and directions

Address: 6000 16th Avenue SW.
Directions from I-5: Exit to West Seattle (Exit #163 northbound, #163A southbound); after crossing the West Seattle Bridge, turn left onto Delridge Way SW. At the third stoplight, turn left onto SW Oregon Street; follow it up the hill, and veer right onto 21st Avenue SW. Take the first left onto SW Dawson Street, which becomes 16th Avenue SW. Continue to the South Seattle Community College, and enter the north parking lot. The garden and arboretum will be on your left shortly after the parking kiosk.

EVEN MORE SPOTS TO CHECK OUT

While the following places are not my first choice to visit or photograph, I've included them here and on the maps for those who want a more in-depth exploration of Seattle. They are worth checking out if you have time and are in the area.

Fishing boat and reflections, Smith Cove Park

Counterbalance Park

(93, north of downtown): This small park is not much to look at during the day, but at night its walls are lit with changing chromatic lights. It's worth a stop if you are in the area and looking for colorful abstracts to photograph. Just get there before 10 p.m., which is when the park closes and the lights go out. The park is northwest of Seattle Center at the northeast corner of Queen Anne Avenue N and Roy Street.

Kinnear Park

(94, north of downtown): This is a two-level park on the west side of Queen Anne Hill with views, some partially obscured by trees, of downtown Seattle, Mount Rainier, Puget Sound, and the Olympics. The lower portion of the park contains a small off-leash area for dogs. The park is several hundred feet downhill from Marshall Park at 899 W Olympic Place and is open from 6:00 a.m. to 10 p.m.

Bhy Kracke Park

(95, north of downtown): Bhy Kracke is a small, little-known, multi-level park on Queen Anne Hill with a view of Lake Union, Gasworks Park, and the Cascade Mountains. There is also a view of downtown and the Space Needle, though it is partially obscured by trees in the foreground. The park's address is 1215 5th Ave N. It is approximately nine blocks east of Kerry Park. The park is open from 4:00 a.m. to 11:30 p.m.

Lakeview Boulevard Bridge

(96, north of downtown): The Lakeview Bridge is an overpass above I-5 that provides a good vantage point to photograph Lake Union and the city skyline from the north along with the freeway, though freeway signs and tall trees partially obstruct or interfere with the view. Sunset shots work well here when the sun is setting to the west or northwest—which reflects on the tall city buildings to the south and reflects on the waters of the lake to the northwest. Night shots can also work here, using long exposures to get light trails from the cars. The overpass is in the 900 block of Lakeview Boulevard E, just west of its intersection with Belmont Avenue E.

Night lights at Counterbalance Park

Elliott Bay Marina and Smith Cove Park

(97 and 98, south Magnolia): Elliott Bay Marina is a public, pleasure craft marina on the north side of Elliott Bay with views of the city, Puget Sound, Mount Rainier, and the cruise ship terminal (when in port, the cruise ships may block the view of downtown). The marina is separated from Elliott Bay by a large breakwater—pleasure boats inside, open water on the outside. A shuttle boat provides access from the end of Dock G to an observation deck on the breakwater. Adjacent to the marina is Smith Cove Park, operated by the Port of Seattle (open 4:00 a.m. to 11:30 p.m.). The park provides a close-up view of cruise ships and large fishing boats. The park is on 23rd Avenue West, south of the Magnolia Bridge (no official address). The marina is west of the park at 2601 W. Marina Place, directly below the Ursula Jenkins Viewpoint.

Hanging flowers at the Elliott Bay Marina

Shilshole Bay Marina

(99, northwest Seattle): The Shilshole marina is a pleasure craft harbor owned by the Port of Seattle with good sunset views over Puget Sound. The marina is at 7001 Seaview Ave NW, a short distance north of the Hiram M. Chittenden Locks.

Sunset Hill Park

(100, northwest Seattle): This park, above Shilshole Bay in western Ballard, has views of Shilshole Bay Marina, Puget Sound, and the Olympics. The park is approximately 1.2 miles north of the Hiram M. Chittenden Locks (take 32nd Street NW north) at 7531 34th Ave NW and is open from 4:00 a.m. to 11:30 p.m.

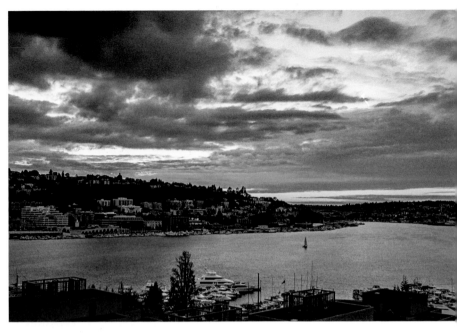
Sunset over Lake Union from the Lakeview Boulevard Bridge

Golden Gardens Park

(101, northwest Seattle): Golden Gardens is another park along the Puget Sound shoreline with exceptional views toward the Olympics; it also offers wetlands and forested areas. There are hiking trails and an off-leash area for dogs. The beach is sandy, unlike many Puget Sound beaches. Campfires are allowed on the beach in designated fire pits. The park's address is 8498 Seaview Place NW. It is just north of the Shilshole Marina. Golden Gardens Park is open from 6:00 a.m. to 11:30 p.m. daily.

Hamilton Viewpoint Park

(102, West Seattle): For more stunning views of Elliott Bay and the Seattle skyline from West Seattle, try Hamilton Viewpoint Park. This viewpoint is on the hill above the northern portion of Harbor Avenue. Its address is 1531 California Way SW, approximately one third of a mile up California Way from its intersection with Harbor Avenue. The viewpoint is open from 4:00 a.m. to 11:30 p.m.

Appendices

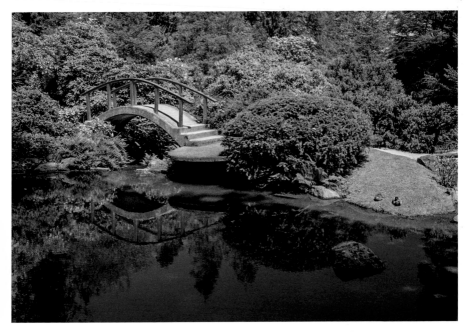

Moon Bridge, Kubota Gardens

CityPASS

If you are going to be in the city for several days and plan to visit several of the major attractions, you can save a bit of money on admission by purchasing a CityPASS. These passes are good for nine consecutive days from first use and can be purchased online or at one of the attractions. The CityPASS gives admission to five major Seattle attractions for $69 (adults). Included are:

1. Space Needle day and night admission (two visits in a twenty-four-hour period)
2. Seattle Aquarium
3. Argosy Cruises Harbor Tour
4. The EMP Museum or the Woodland Park Zoo
5. Pacific Science Center (including an IMAX movie) or the Chihuly Garden and Glass.

The pass is available online at www.citypass.com/seattle.

Other Seattle Photography References

Nature in the City, Seattle: Walks, Hikes, Wildlife, Natural Wonders, by Maria Dolan and Kathryn True (Mountaineers Books, 2003). If you like nature photography, check out over forty natural places in and around Seattle described in this book.

The Photographer's Guide to Puget Sound and Northwest Washington, by Rod Barbee (Countryman Press, 2007). Barbee provides descriptions, photography hints, and directions to scenic destinations not only in Seattle, but also throughout northwestern Washington. All destinations in the book are within a day's drive of Seattle.

Photographer's Guide to Seattle, http://seattlephotoadventures.blogspot.com/, blog by Dharshan. Though this blog hasn't been kept up since February 2011, it is a good reference that highlights many landscape, nature, and travel spots in the Seattle area.

CityPASS allows a discounted entry to major attractions, such as the Seattle Aquarium.

Ratings for Destinations

Tourist Value and Photographic Value

With a focus on both tourism and photography, not all the places described in this book are naturally suited to both pursuits. In an attempt to quantify the value of the places described in the book, I've rated them on their tourist and photographic value. Obviously these ratings are somewhat biased by my own likes and dislikes, but they, along with the place descriptions in the text, can provide the reader with a subjective guide to organize their visit to Seattle.

Ratings are based on a zero- to five-star scale:

Tourist Value

–................Not very interesting, little to nothing to do

☆................Mildly interesting, minor tourist activities, don't go out of your way

☆☆.............Moderately interesting, some fun activities, visit if time permits

☆☆☆..........Very interesting, fun activities, try to fit it in

☆☆☆☆........Outstanding attraction, many engaging activities for tourists, worthy of any itinerary

☆☆☆☆☆Best Seattle has to offer, must-see attraction, must-do activities

Photographic Value

–................Not much to photograph

☆................Worth a quick snapshot if in the area

☆☆.............Good scenic or photographic value

☆☆☆..........Very good photographic opportunity

☆☆☆☆........Outstandingly scenic with great photographic opportunities

☆☆☆☆☆Seattle's best photographic scenes, excellent photographic opportunities

REF. #	PLACE OR ATTRACTION	PAGE	TOURIST VALUE	PHOTOGRAPHIC VALUE
1	Space Needle	18	★★★★★	★★★★
2	EMP	20	★★★★	★★★★
3	Chihuly Garden and Glass	22	★★★★	★★★★★
4	Pacific Science Center	23	★★★★	★★★
	NOTE: photo rating for building architecture and tropical butterfly house			
5	Seattle Monorail	25	★★★	★★
6	International Fountain and Center Grounds	26	★★★	★★★
7	Pike Place Market: Main and North Arcades	29	★★★★★	★★★★★
8	Pike Place Market: Lower Levels	29	★★	★★
9	Market Theater Gum Wall	31	★★★	★★★
10	Victor Steinbrueck Park	32	★★	★★
11	Washington State Ferries	36	★★★★★	★★★★★
12	Bainbridge Island	38	★★★	★★★
13	Bremerton: Harborside Park	39	★★	★★
14	Bremerton: Puget Sound Navy Museum	39	★★★	★★
15	Bremerton: USS *Turner Joy* US Naval Destroyer Museum	39	★★★	★★★
16	Seattle Great Wheel	41	★★★★	★★★
17	Waterfront Park	43	★★	★★★
18	Seattle Aquarium	44	★★★★	★★★★
19	Piers 62 and 63	45	★	★★
20	Bell Street Pier and Harbor	46	★★	★★★
21	Olympic Sculpture Park	47	★★★	★★★
22	Myrtle Edwards Park	48	★	★★
23	Centennial Park	48	★	★★
24	Seattle Art Museum	51	★★★★	★★★
25	Starbucks Reserve Roastery & Tasting Room	52	★★★	★★
26	Frye Art Museum	53	★★★	★★
27	Seattle Central Library	54	–	★★★★
28	Columbia Center (Sky View Observatory)	57	★★★★	★★★
29	Smith Tower	57	★★★	★★★

REF. #	PLACE OR ATTRACTION	PAGE	TOURIST VALUE	PHOTOGRAPHIC VALUE
30	Pioneer Square	59	★★★★	★★★
	NOTE: ratings for Pioneer Square district as a whole			
31	Seattle Underground Tour	59	★★★	–
32	Occidental Square	60	★	★
33	Waterfall Garden	60	★	★★
34	Klondike Gold Rush National Historic Park	60	★★★★	★★
	NOTE: photographically rates one star higher for walking tour			
35	Union Station	62	★	★★★
36	International District: Dragons	63	★★★	★★★
	NOTE: ratings for International District as a whole			
37	International District: Chinese Gates	63	★★	★★
38	Kobe Terrace Park	63	★	★★
	NOTE: rates one star higher when cherry trees are blooming			
39	Hing Hay Park	64	★	★★
	NOTE: rates at four stars during festivals			
40	Wing Luke Museum of the Asian Pacific American Experience	64	★★★★	★★★
41	Seattle Pinball Museum	64	★★	–
42	Rizal Viewpoint	66	★	★★★★
43	Kerry Viewpoint	69	★★	★★★★★
	NOTE: tourist value rating for scenery only (no activities)			
44	Betty Bowen Viewpoint	70	★	★★★
45	Parson Gardens	70	★	★★
	NOTE: ratings for spring blooming season only			
46	Center for Wooden Boats	71	★★★★★	★★★★★
47	Historic Ships Wharf	72	★★★	★★★
48	Museum of History and Industry	74	★★★	★★★
49	University of Washington: Cherry Trees	76	★★	★★★★
	NOTE: ratings for spring blooming season only			
50	University of Washington: Red Square	78	★	★★
51	University of Washington: Suzzallo Library	78	★	★★★★

REF. #	PLACE OR ATTRACTION	PAGE	TOURIST VALUE	PHOTOGRAPHIC VALUE
52	University of Washington: Rainier Vista	78	★	★★★★
53	Burke Museum of Natural History	80	★★★	★★
54	Henry Art Gallery	81	★★★	★★
55	Washington Park Arboretum	82	★★	★★★
56	Seattle Japanese Garden	82	★★★	★★★★
57	Volunteer Park Conservatory	85	★★	★★★
58	Seattle Asian Art Museum	86	★★	★★
59	Volunteer Park Water Tower	86	★★	★
60	Lake View Cemetery	88	★★	★★
61	Northwest African American Museum	88	★★★	★★
62	Jimi Hendrix Park	89	★	★
NOTE: under construction as this went to press				
63	East Portal Viewpoint	90	–	★
64	Madrona Park	91	★	★
65	Ursula Judkins Viewpoint	93	–	★★
NOTE: photo rating five stars during spring full moon				
66	Parkmont Place	95	★	★★
67	Magnolia Park	95	★	★★
68	Discovery Park	98	★★★	★★★
69	Fort Lawton Historic District	98	★	★★
70	West Point Lighthouse	98	★★	★★★
71	Fort Lawton Military Cemetery	98	★★	★★
72	Seafair Indian Days Pow Wow	98	★★★★★	★★★★★
73	Fishermen's Terminal	101	★★	★★★
74	Hiram Chittenden Locks	102	★★★★	★★★
75	Chittenden Locks Fish Ladder	102	★★★	★
76	Carl S. English Bontanical Gardens	103	★	★★
77	Carkeek Park	104	★	★★
78	Gasworks Park	106	★★	★★★
79	Fremont	108	★★★	★★
NOTE: rates at four stars during festivals				
80	Aurora Avenue Bridge	108	–	★★★
81	Woodland Park Zoo	110	★★★	★★★

REF. #	PLACE OR ATTRACTION	PAGE	TOURIST VALUE	PHOTOGRAPHIC VALUE
82	Seward Park	113	★	★★
83	Kubota Garden	114	★★	★★★★
NOTE: photo rating for spring and fall seasons				
84	Museum of Flight	115	★★★★★	★★★
85	Jack Block Park	119	★	★★
86	Seacrest Park	119	★★	★★★★
87	Alki Beach	121	★★★	★★
88	Alki Point Lighthouse	121	★★	★★
NOTE: difficult to photograph due to access restrictions				
89	Belvedere Viewpoint	122	–	★★
90	Lincoln Park	123	★★	★★★
91	Seattle Chinese Garden	124	★★★	★★★★
92	South Seattle Community College Arboretum	124	★	★★
93	Counterbalance Park	126	–	★
NOTE: rating is for night photography only				
94	Kinnear Park	126	–	★
95	Bhy Kracke Park	126	–	★
96	Lakeview Boulevard Bridge	126	–	★★
97	Elliott Bay Marina	127	★	★
98	Smith Cove Park	127	★	★
99	Shilshole Bay Marina	127	–	★
100	Sunset Hill Park	127	–	★★
101	Golden Gardens Park	128	★	★★
102	Hamilton Viewpoint Park	128	–	★★

Endnotes

Chapter 1

1. "Fuijifilm names the Most Photogenic Cities in the United States," PR Newsire, May 2001, www.prnewswire.com/news-releases/fujifilm-names-the-most-photogenic-cities-in-the-united-states-san-francisco-scores-first-in-statistical-survey-of-top-cities-71552842.html.

2. Precipitation data from National Oceanic and Atmospheric Administration (NOAA) records for the thirty-year period of 1971–2000, as presented on www.infoplease.com.

3. Defined as when clouds cover more than three-quarters of the sky.

4. National Oceanic and Atmospheric Adminstration (NOAA) records, as presented on www.currentresults.com.

5. Weatherbase.com.

6. Seattle Parks and Recreation, www.seattle.gov/parks/quickfacts.htm.

Chapter 2

1. Richard Seven, "After 10 Years, Experience Music Project is Still Perplexing," Pacific NW Magazine, Seattle Times, June 5, 2010.

2. Seattle Center Monorail web site, www.seattlemonorail.com.

Chapter 3

1. The Desimone Bridge once connected the North Arcade with the Municipal Market Building on the west side of Western Avenue. The Municipal Market Building was demolished after a 1974 fire, but the bridge remains.

2. "Germy Tourist Spots," CNN web site July 20, 2009, edition.cnn.com/2009/TRAVEL/07/20/germy.tourist.spots.

3. Evan Bush, "Seattle Gum-Wall Time-Lapse," Nov. 16, 2015, Seattle Times, http://www.seattletimes.com/seattle-news/how-much-gum-dotted-pike-place-markets-post-alley.

Chapter 4

1. A minimum two-week advance notice is required. Call the Seattle Fire Department at 206.386.1400. Additionally, during the construction of the new waterfront seawall tours will not be available.

2. The City of Bainbridge Island was formed in 1991 when the former city of Winslow annexed the whole island and changed its name.

3. United States Census Bureau, census.gov/quickfacts.

4. A walking map of the Winslow neighborhood can be viewed and downloaded at www.bainbridgewa.gov/documentcenter/view/634.

5. The date of the demolition of the Alaskan Way Viaduct has not been set. It will be torn down after the new State Route 99 tunnel is completed. As of the end of 2015, the tunnel's opening date is projected at April 2018.

6. The Post-Intelligencer globe is a local Seattle icon. It is the symbol of the former print newspaper, the Seattle Post-Intelligencer, better known as the Seattle P-I. The newspaper is now printed online only. The globe sits atop the paper's former headquarters next to Myrtle Edwards Park. In

2012, the globe was donated to the Museum of History and Industry, which currently plans to move it to a new but permanent location somewhere near Myrtle Edwards Park (Jake Ellison, "P-I Globe Likely Headed for Myrtle Edwards Park 'Vicinity,'" March 2, 2015, seattlepi.com.)

Chapter 5

1. Walking between the listed walking-tour sites, in the order given, without going to Rizal Park is approximately 1.2 miles. Rizal Park is approximately 0.8 miles farther.

2. Google search run on June 13, 2015.

Chapter 6

1. Yesler Way is the boundary between two different street grid patterns so that the streets north of Yesler Way do not line up with the streets south of Yesler. Consequently, the northern border of the Pioneer Square district zig-zags along several streets.

2. According to the Annie E. Casey Foundation website, Annie E. Casey was a widow who raised four children near Seattle. Her oldest son, Jim, started a messenger service to help support the family. That messenger service later became UPS. The foundation was started in 1948 to honor Annie E. Casey.

Chapter 8

1. "History of the UW Landscape," Grounds Management page, University of Washington website, depts.washington.edu/grounds/explore/landscape_history.php.

2. "About Suzzaloo & Allen Libraries," University of Washington website, www.lib.washington.edu/suzzallo/visit/about

3. "About us," Burke Museum website, www.burkemuseum.org/info/about.

4. Ethnology Collections Database, Burke Museum website, collections.burkemuseum.org/ethnology/index.php.

Chapter 9

1. "About the Burke," The Friends of the Conservatory website, www.volunteerpark-conservatory.org/about-us.

2. "History of Volunteer park Conservatory," The Friends of the Conservatory website, www.volunteerparkconservatory.org/about-us/history-of-the-conservatory."

Chapter 11

1. The Pow Wow is usually held annually, however, it is occasionally cancelled due to lack of funding. Be sure to check the Pow Wow's website for details, www.unitedindians.org.

Chapter 12

1. The Troll is copyrighted by sculptors Steve Badanes, Will Martin, Donna Walter, and Ross Whitehead. The image of The Troll is used here with permission.

Chapter 13

1. "$30M to the Museum of Flight for STEM Education," Business Wire website, www.businesswire.com/news/home/20150723006303/en/30M-Museum-Flight-STEM-Education.

Index

Notes

Acknowledgments

This book would not have been possible without the support of friends and family who encouraged me throughout the book's production. Thank you all. I'd also like to give a special thanks to David Pawlan, Peter Schilling, Ali, Richard Eltrich, Gerald Reed, Roy A. Burnett, John Kirry, Mike Krautkramer, Jennifer Walters, Tom Ryan, Janelle Becker, Justin Soderquist, Alexander Lyudin, Jason Johnson, Marriem Bradford, Annie Wynn, John M. Woods, Marisa Erven, Matt Keller, Richard Shipley, Bas Rabeling, Andrae McDonald, TheWhiteRose, Bruce Valles, Doug Sala, Peter Halbersma, Jack Falskow, Peter Kallio, Jerry Flynn, Doug Pine, Christopher Slaughter, Mark Cole, John Prudente, Joe Nekrasz, Sue Burnett, Hanspeter Leupin, Martin Clifford, Samuel Tremblay, Christy, Douglas King, Stephen Stick Hazen, Tony Watson, Lemonde, Christopher Levinson, D. Ivanovich, Mark Patton, R0drigo Perez [Mx], Chloé Freidman, Kderbyshire, Seth Yutzy, WillYp777, omprakash, Ken's Lil' Sister, Sterling, Mary Couse, johnsaunders, Bobby Kenis, Kelli Smith, Cindy and Brian Page, and Irene Graham who gave financial support to the project either directly or through Kickstarter. Your support for the project was amazing.

I'd also like to thank Maggie Foran, Tom Manders, Christopher Cox, Bob Miller, and Amber, author of the blog *Bookgraphy Reviews*, for being beta readers of the original ebook version of this work. Also thanks to David Weiler with Robinson Noble, who made the maps for me while suffering my many revisions, and my son Brooks for finding the monkey on my back. And finally, my deepest thanks go to my spouse, Tanya Sorenson Becker, for all her support and her excellent editing of the text.

Author and photographer, Joe Becker, *courtesy of Brooks Becker*

JOE BECKER is an award-winning freelance photographer and author living in Tacoma, Washington, with his wife and 160-pound Newfoundland. In addition to being a photographer, Joe is a practicing hydrogeologist. His images have been published by the National Geographic Society, as well as in books and magazines around the world, including *EOS magazine, Northwest Travel Magazine*, and others. To see more of his work, or to contact Joe, visit his website at SeldomSeenPhoto.com or his blog at JoeBeckerPhoto.wordpress.com.